IMAGES
of America

KNOXVILLE

IMAGES
of America

KNOXVILLE

Ed Hooper

ARCADIA
PUBLISHING

Published by Arcadia Publishing
Charleston, South Carolina

Printed in the United States of America

Library of Congress Catalog Card Number: 2003107003

For all general information contact Arcadia Publishing at:
Telephone 843-853-2070
Fax 843-853-0044
E-mail sales@arcadiapublishing.com
For customer service and orders:
Toll-Free 1-888-313-2665

Visit us on the Internet at www.arcadiapublishing.com

CONTENTS

Introduction 7

1. Gay Street 9

2. Agriculture, Enterprise, and Industry 25

3. The "Can Do" Company 49

4. Planes, Trains, and Automobiles 65

5. To Serve and Protect 75

6. Churches and Charity 93

7. Knoxville After Hours 107

Acknowledgments 127

Bibliography 128

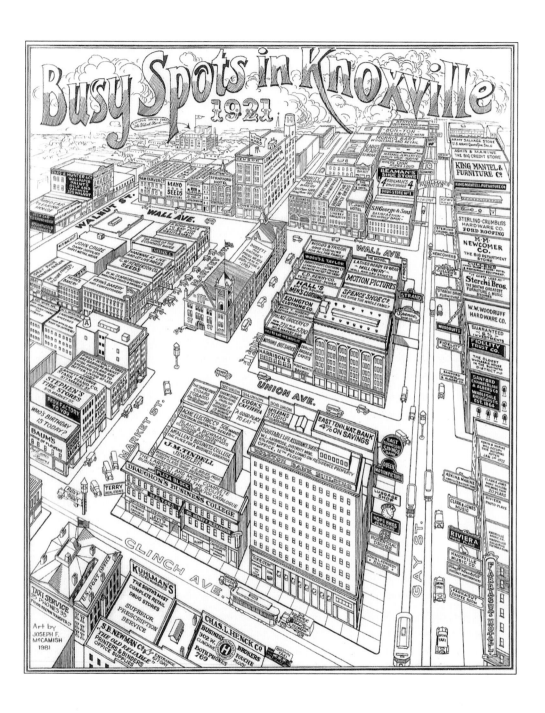

6

INTRODUCTION

These photographic images show snapshots of a city from its earliest days to its development into a thriving metropolitan area of the 21st century.

Knoxville has held many nicknames throughout its 213-year history. It began as a small fort on the Tennessee River just below where the French Broad and Holston Rivers meet to form the region's primary river. The fertile and rich Tennessee Valley immediately became its principal source of revenue as farmers, ranchers, and businessmen transported their goods to the city for shipment over land to the east or down the river to New Orleans.

Before the move towards statehood, the frontier outpost served as a capitol for the "Territorial Land Southwest of the Ohio River" and the official residence of Gov. William Blount. The lands that formed the city proper came through grants to settlers given for military service in the American Revolutionary War. William Blount's local influence and his desired associations with the nation's leaders led the town to be named for then-United States Secretary of War Henry Knox.

From its founding in 1791, the land around the city's most prominent structures—James White's fort and Gov. William Blount's home—sprang to life with homes, churches, and businesses. Forging the frontier outpost into a major city was not an accident but a planned driving force for the early Scotch-Irish settlers who had a vision of it becoming America's principal city west of the Appalachians.

When President George Washington signed the legislation making Tennessee a state in 1796, Knoxville became its first capitol.

The street where the Army Blockhouse fort was built to guard against Indian attacks quickly became the primary business district in the city. The road leading to it was called Blockhouse Street, but, as the city grew around it, the name was changed from Court Street to Market Street and, then, to Broad Street. By 1802, merchants and dry good stores were doing a tremendous amount of trade with Baltimore, Maryland's Gay Street merchants. It was the nearest big city and the most accessible to businesses purchasing wholesale merchandise.

The city was also starting to become a principal exporter of raw and natural goods that soon attracted new residents, investors, and entrepreneurs. Whether to mimic or reflect the booming business in Knoxville, merchants renamed the city's main economic roadway Gay Street and that designation has remained for the last 200 years.

Gay Street has been a window on the growth, development, decline, and rebirth of Knoxville as an American city. The city has always served as a crossroads of sorts for those traveling south,

heading west, or deciding to make their home in the Southern Appalachian region. From future King of France Louis Philip's visit following the Revolutionary War to celebrity statesmen, entertainers, and presidents, Knoxville has played host to some of the greatest names in United States history over the last two centuries.

The courthouse, federal buildings, churches, homes, and businesses that clustered around the main thoroughfare formed the nucleus of what was a major metropolitan area for the southeastern United States. Now, as then, all roads downtown lead to Gay Street and all things Knoxville come from it.

It is a decidedly Southern city but different in its cultural development. The Scotch-Irish founders were the dominant ethnic group, but the city became a representation of the American melting pot. Swiss, English, Dutch, Irish, German, Greek, African, and Spanish families' cultural influences played major roles in the development of Knoxville.

While the city does boast one of the oldest historical societies in the United States, preserving the history of Knoxville has been a major political issue over the years to residents and officials alike. When a historic home was in danger of being destroyed in 2001 to build a parking lot for a golf course, a massive groundswell of angry residents demanded Knoxville do more than pay lip service to its rich historical past. Mayor Victor Ashe pushed to incorporate into the City Charter an amendment that now requires an annual mayoral "state of historic preservation address" and requires all property slated for demolition to be studied for its historical value. The amendment was a pioneering move for the city and attracted the attention of the National Trust for Historic Preservation and now other cities across the nation are looking at incorporating a similar law into their charters.

Photography was slow in coming to the region and photographs of the city proper did not start occurring until the late 1850s. The photographs of Knoxville following the War Between the States show a city's rebirth and the growth of the industries it fell upon to pull itself from the brink of post-war bankruptcy to a pinnacle of success and wealth. Gay Street's appearance would change dramatically in this time period and advance the city's position to an important place in American history.

Knoxville's past as seen here is a rare look into one of the South's premier early metropolitan areas. Most photographs from the city's past are scattered, deteriorated beyond use, or so closely guarded that access to them is impossible for the average citizen. Those which have been published through the years have often been improperly labeled or misidentified.

The majority of the photos in these pages come from a meticulously labeled collection gathered over time by Gary Crowder. He grew up on Gay Street in the 1940s and 1950s and his father had the distinction of owning a popcorn stand noted as the smallest business to ever sit on Knoxville's most famous thoroughfare. During this time, a period of change not uncommon to the city's main business district began occurring and the Crowder family saw first-hand the history of Knoxville as buildings and roadways were pulled away to renovate and modernize the business district.

Until his death, Gary Crowder amassed hundreds of rare images and photos. It was through the efforts of his brother Mike that the family managed to preserve one of the most remarkable collections known to exist of Knoxville.

One

GAY STREET

This is the street where Knoxville was founded. The fertile valley surrounding the city and the mountains to its east are capable of producing a wide variety of consumer products from the abundance of natural resources available. When river transport was the only way of getting goods to major ports, Gay Street felt a sense of economic power because it was located in the largest settlement in East Tennessee and at the point where the French Broad and Holston Rivers form the Tennessee River.

Through Indian raids and man-made or natural disasters, the city's main business district and thoroughfare has weathered it all. The Civil War almost destroyed it, but as America returned to its cycles of business and growth, the city lurched forward and Gay Street began an unexpected rise towards national prominence. The placement of railroad yards near Gay Street business offices added incentives to wholesalers representing a variety of resources for which there was national demand. Retail outlets also prospered as outlying settlements and communities created a demand for the goods and services Knoxville provided and the rails delivered.

Being the crossroads of the South at the foot of the Appalachian Mountains, however, meant the city never entirely lost its frontier flavor in spite of the well-intentioned civic and social leaders who made their home here. The unique character gave Knoxville a rounded personality common to every great city and, along with those who called it home, attracted the infamous as well as national celebrities to the ever-changing pavement of Gay Street.

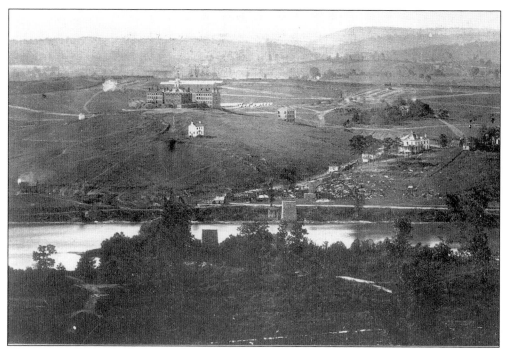

This is one of the oldest photos taken from the Union's Fort Stanley looking north across the Tennessee River at the University of Tennessee in 1868. The land is barren as both Union and Confederate soldiers cut down trees throughout the city to build earthworks, campsites, and fires and to clear obstructions from the armies' field of view. The city was devastated by the loss and the barren landscape posed numerous problems during the rainy seasons.

This is one of the oldest known photographs of Gay Street, taken in 1868, looking north at the ridge where Fort Stanley looked down on the city. The shingles name a number of companies that were the bedrock of Knoxville's early business community. Of particular interest is the M. Stern Drygoods Store, which was owned by one the city's earliest Jewish settlers. Jewish worship services were held on its second floor until a new location was found.

The Lamar Hotel was one of the city's earliest premier lodging businesses. Five United States presidents resided here while in Knoxville. This is a political rally held in 1875 on the balcony and often misidentified in other publications as a speech delivered by Rutherford B. Hayes in the city. The photograph is, in fact, of a Banner Presentation to the McKinney Guard on June 6, 1876.

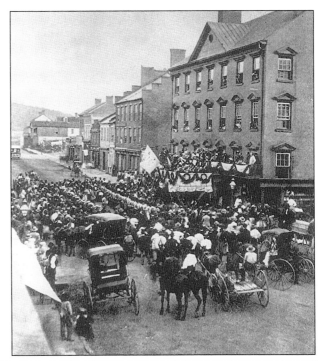

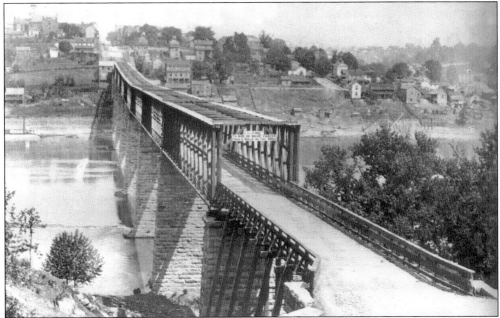

This was the second Gay Street bridge built over the Tennessee River after the first one was blown off of the underpinnings by a gust of wind. The bridge was nicknamed "Old Shaky" because it sagged in the middle and rattled when used. The trek over the privately-owned toll bridge was such that when the county finally purchased it, they strictly enforced the first speed limit in the city by posting a sign over it that read: "$5 Fine to Ride or Drive faster than a Walk on this Bridge." Until the bridges were built, the only way to get to Knoxville from South Knox County was by ferryboats.

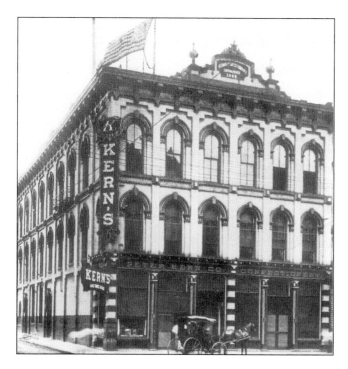

German immigrant Peter Kern was a wounded Confederate soldier who was trapped in Knoxville on his way to Richmond, Virginia, when the Union Army blocked the road to the city. A German baker took him in and the two formed a partnership. Kern later bought out his benefactor and Kern's bread, cakes, ice cream, and candy went on to become known throughout the South. He bought this building at the corner of Union and Market Streets, just off of Gay Street, in 1876 and the ice cream parlor became a center of social life in the city. Peter Kern served in numerous elected offices and as mayor of Knoxville in 1890.

The C.M. McClung Company was a leader in helping make Knoxville the third largest wholesaling city in the South, giving rise to a strong middle class in the city who worked as salesmen or "drummers." McClung entered business in 1877 and five years later bought out his partners. The wholesaling business in Knoxville included 50 such companies doing an annual business of more than $50 million per year by the early 1900s—many also maintained offices in Boston and New York. Here the building is decorated for a trade festival in 1889.

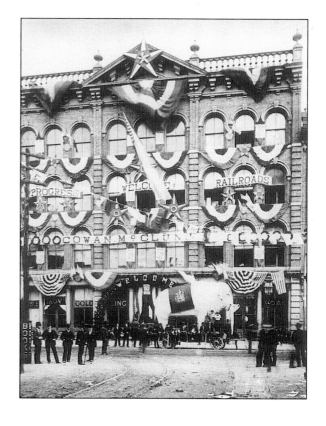

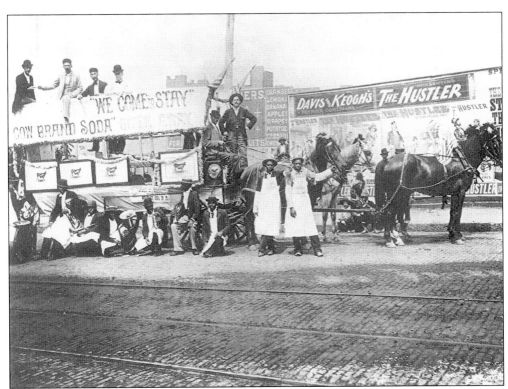

This advertising wagon (c. 1890) was a popular way for retailers to market their goods at festivals and celebrations held in Knoxville. They often mixed agricultural events with trade shows, which drew people downtown to shop. The annual fall festival is still a fixture in Knoxville culture and the mixing of agriculture and trade events draws tens of thousands to the city each year.

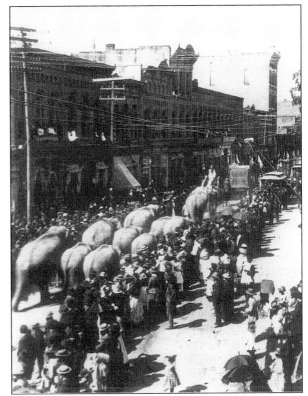

A parade of circus elephants around onlookers and horse-drawn streetcars on the 500 block of Gay Street in the 1880s was one of the most obvious ways of alerting people that the circus was in town. Performers and other acts would often make the march with the elephants to the big top.

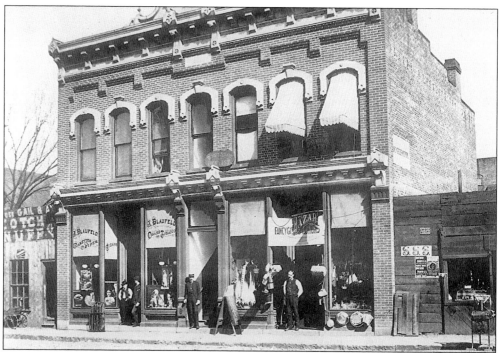

The Plaza Block Building housed the popular Blaufield Tobacconist store and other retailers with offices upstairs for dental, medical, and legal professionals. While wholesale businesses dominated Gay Street, smaller retail stores like these found a prosperous place in the business district.

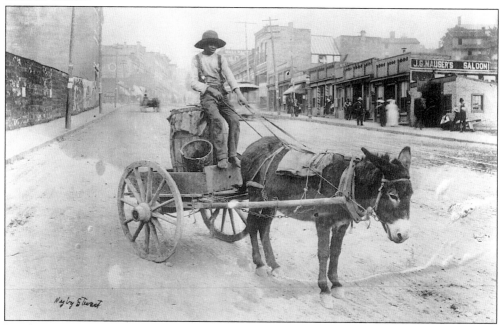

Drinking water was a necessity in Knoxville for shoppers, businessmen, and employees. This image of an African-American child selling water on the street was common in many locations throughout the city.

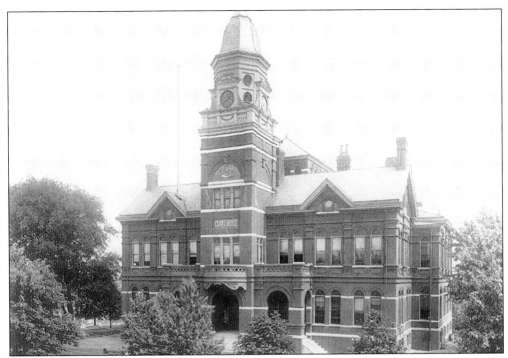

The Knox County Courthouse was built in 1884 across the street from the old one. It sits on the location of the old Block House Fort that gave its name to Gay Street when the city was founded. Additions were later constructed to accommodate the county's growing court system.

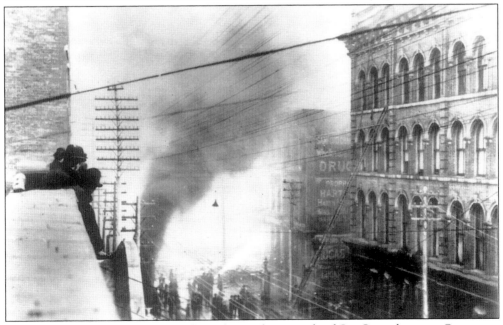

On April 8, 1897, a small fire started on a lot on the east side of Gay Street between Commerce and Union Avenues. It was in the center of the wholesale houses that were the rock of Knoxville's economy. The fire was not discovered until 3:45 a.m. and Gay Street went up like a torch.

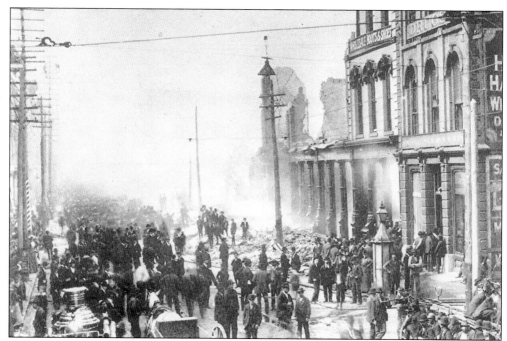

The fire's dramatic size led Knoxville's fire chief to telegraph Chattanooga for help. The railroad cleared a track and Chattanooga firemen and their equipment raced to Knoxville's aid in less than two hours. The two fire departments worked side by side for days until the blaze was extinguished.

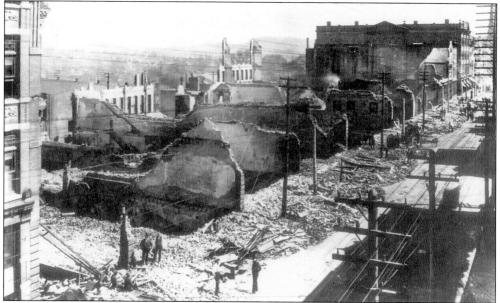

The Gay Street fire took 5 lives and destroyed 13 buildings on Gay Street and 6 on State Street, while damaging 21 other buildings. It was the most devastating fire in the city's history and its cost to the city gave it the name "The Million Dollar Fire"—a name in which early business leaders took pride, because the city actually had one million dollars worth of property in the business district. The section was rebuilt in less than a year.

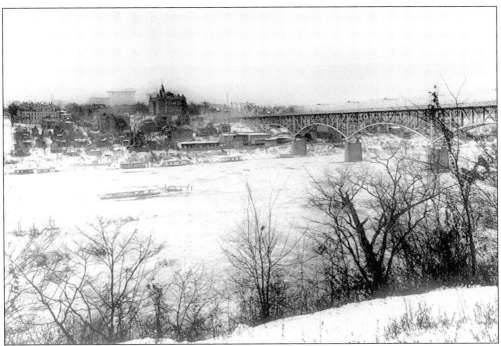

This photo was taken in 1917 of the Gay Street Bridge from the south shore and one of the few times in the city's history that the Tennessee River was frozen solid.

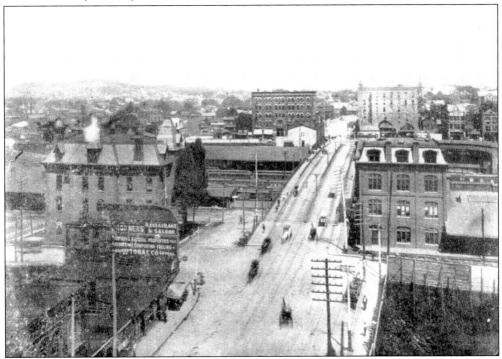

This is an image of the narrow bridge on Gay Street that crossed over the train yards of downtown Knoxville. It was the only thing that connected North Knoxville to the city much in the same way the Gay Street Bridge connected it to South Knox County.

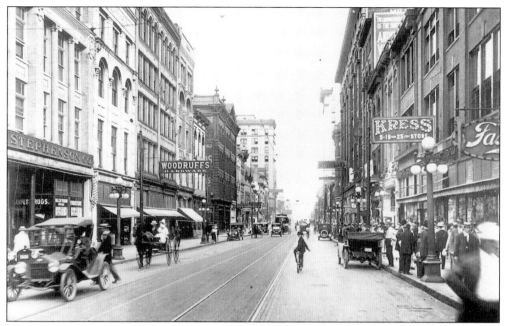

The city's main business district during working hours is shown in this photo of Gay Street looking south (*c.* 1913). Woodruffs Hardware was owned and operated by W.W. Woodruff, who was at one time Knoxville's biggest retailer. He was a leader in reestablishing the Baptist faith and known for donating church-bells to every new Baptist church built in the region.

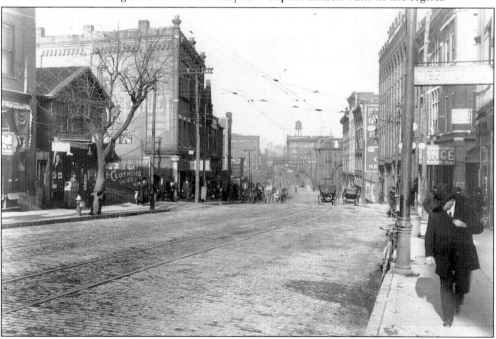

This photograph looks north on Gay Street from Vine Avenue *c.* 1917 in front of the Western Union Telegraph Company. The bridge over the railroad yards connecting downtown to North Knoxville continued becoming difficult to manage as automobiles, streetcars, and horses competed for space.

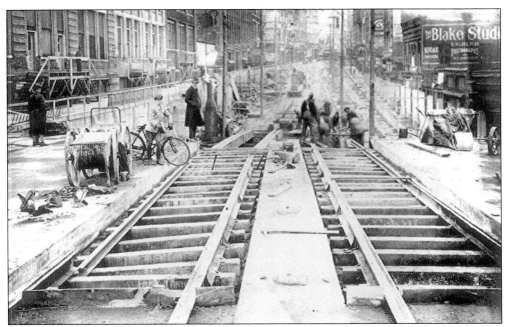

In 1919, Knoxville began the massive project of raising Gay Street 15 feet over the Southern Railroad Yards to do away with the bridge. The one-story buildings that were completely covered by the new road still remain under the street and are still accessible through basements of some of the original buildings.

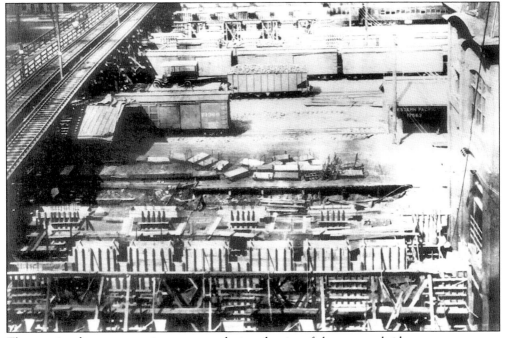

The massive downtown project meant reducing the size of the current bridge to a narrow one with a streetcar track to one side. The project took a year to complete and gave Knoxville the extension it needed to connect the two sides of the city and allowed new businesses to continue establishing at the heart of downtown.

The Hotel Atkin at the corner of Gay and Deport Streets was built in 1910 and was headquarters to Knoxville's traveling salesmen, who traveled by rail. It was the first hotel to have "sample rooms" for salesmen to set up their wares and advertised in 1923 as having "200 fireproof" rooms. The raised platform box was for policemen in the city to operate traffic signals and keep an eye on downtown.

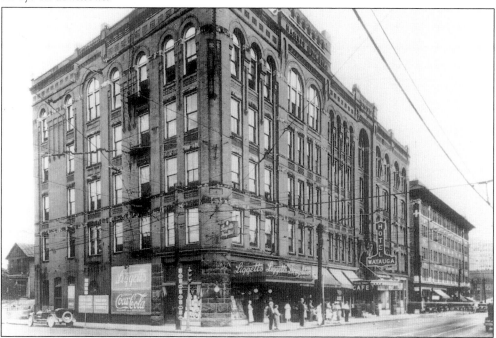

The adjoining Harris Building housed the Watauga Hotel, Liggett's Drug Store, which was one of the city's most popular, and a small café known as the Regas Brothers—one of the first Greek families to establish themselves in Knoxville.

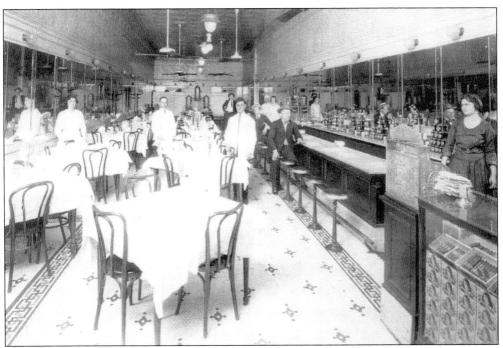

The Regas Brothers Café set up near the Southern Railroad Yards and proved to be a popular gathering place for railroad workers and passengers alike. The small business was a success in Knoxville and moved from its first location to another in order to broaden the space needed for its growing numbers of customers.

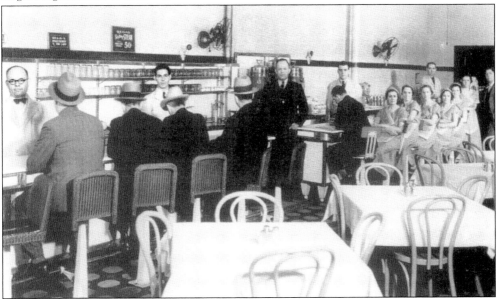

Regas Brothers Café finally came to rest on the corner of Magnolia and Gay Streets when it became known as Regas's Restaurant. The successful enterprise and the success of the Regas brothers attracted numerous Greek families to Knoxville from the old country. During the ensuing years, Greek families would eventually own 41 of 43 restaurants and cafes in Knoxville. Regas's Restaurant still operates and is considered one of the city's premier dining experiences.

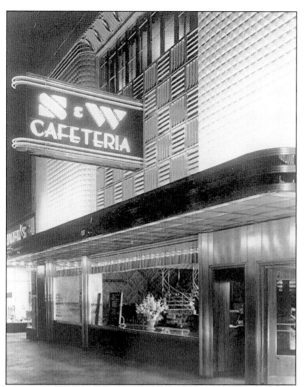

One of the most popular lunch and dinner spots on Gay Street was the S&W Cafeteria. The business had two floors and a number of private rooms where groups and organizations could hold gatherings, which brought a unique nightlife to the city's downtown business section.

This lunchtime scene in the S&W Cafeteria in 1939 shows how popular the place was with downtown business people. Music was provided by an organ at the front of a sweeping stairway that led to the second floor.

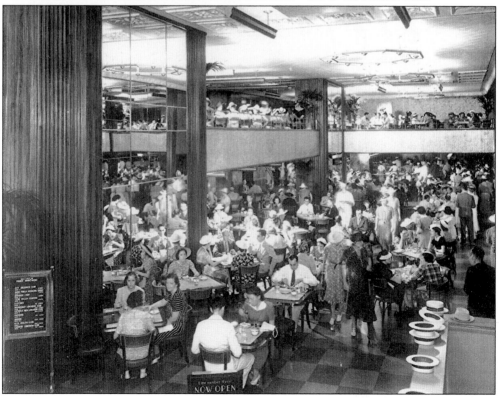

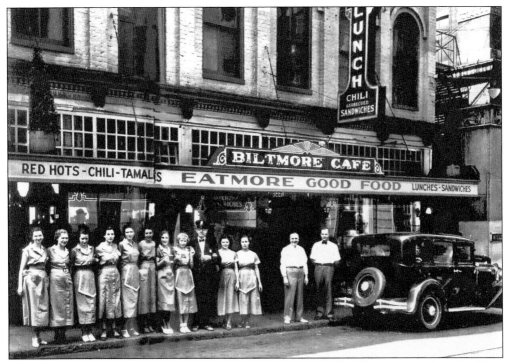

Another popular cafeteria was the Biltmore located in the Miller's Department Store Building on Gay Street. This 1935 scene shows the waitresses and owners of the establishment posing outside for a photograph.

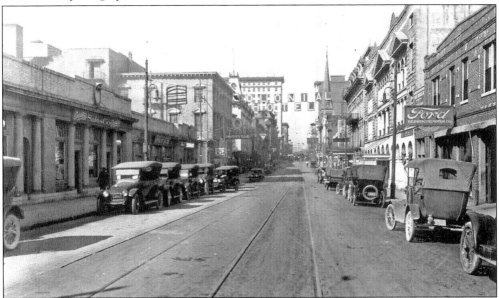

As Knoxville's wholesale industry began to decline, a variety of businesses began moving into the downtown business section. This shows a scene from the Roaring Twenties in Knoxville and the city's first Ford Automobile dealership. While the streetcar was still the primary means of transportation to downtown, many middle class residents turned to the automobile as their chief means of transportation as they became more affordable.

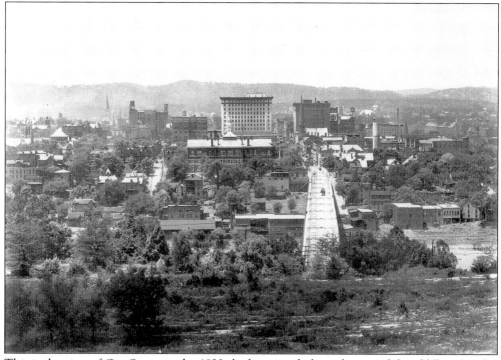

This is the view of Gay Street in the 1930s looking north from the site of the old Fort Stanley across the Gay Street bridge. The city's downtown business district shows the back of the courthouse and a shallow Tennessee River under the bridge. Because of the varying levels, the river had numerous islands and one can still see some of the last family residences downtown.

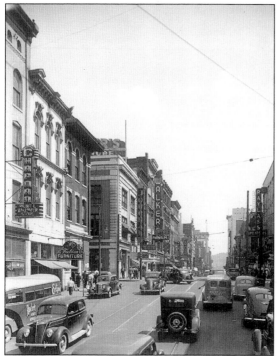

In the 1940s, Gay Street looked like a different place than it had in years past. There were a number of original buildings still standing, but the city had taken on a new character. Wholesaling and other industries, which had once propped up the city's economy, were disappearing and being replaced with new enterprises. The Tennessee Valley Authority headquartered itself in the city and nearby Oak Ridge; they brought with them massive government payrolls and a new wealth to the region.

Two

AGRICULTURE, ENTERPRISE, AND INDUSTRY

From the first time European explorers gazed upon the Tennessee Valley, they saw a land rich with expectations for farming. Hernando De Soto sent a scouting party into the region based on rumors of gold being here, but they returned with only a handful of some unknown mineral not worthy of his party's attention.

When Knoxville founder James White and the first settlers landed on the banks of what would become Knoxville, all immediately took to farming—not only to survive, but to develop a basic agrarian economy and establish commercial trade. The early Scotch-Irish settlers were nothing if not self-sufficient and soon were making use of the Tennessee River to get goods to the East Coast as well as downstream to New Orleans.

As the United States grew in succeeding years, the demand for natural resources to build, feed, and power the nation led to Knoxville becoming an important source of raw material and supplies.

Those who came to carve a nation out of the wilderness found no better place than the Tennessee Valley to start. Troubles with hostile Native Americans were resolved by the 1820s and that led to a boom in not only what could be taken from the crops and the ranches, but also from underneath the ground itself. There were some unique unknown qualities beneath the rich soil of the Tennessee Valley that would find their place in the growing North American economy and in the history of the United States—industries that would become trademarks of Tennessee.

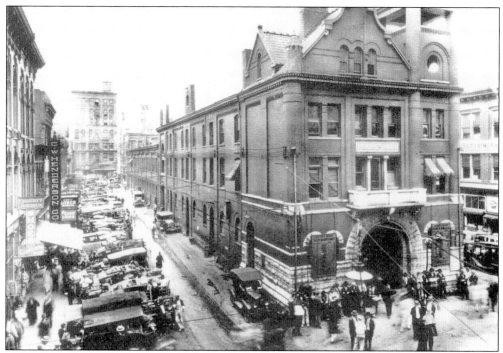

The Knoxville Market House, which gave the downtown section the name "Market Square Mall," was first built in 1854 and was the economic center for the region's farmers and ranchers. It was used as an ammunition depot during the Civil War and was rebuilt in 1897. It featured numerous stalls, restaurants, and offices, and remained a vital part of the city's downtown success well into the 1950s.

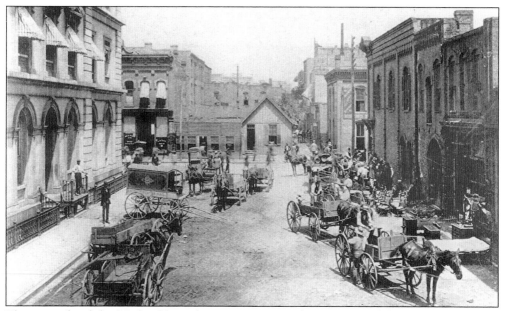

This is a side of the Market House known as "watermelon row." Local farmers and ranchers who could not afford to rent a stall in the market were allowed to set up outside and sell their products, often at cheaper prices, which made it a popular place for many Knoxvillians.

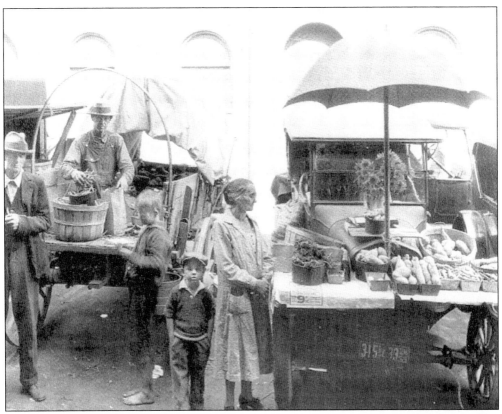

This photo shows a close-up of "watermelon row" shopping in the 1920s. There were a variety of products available depending on the season. As there was a new wave of residents moving to Knoxville from the mountains for better opportunities, the market was a good place for the farmers among them to make extra money.

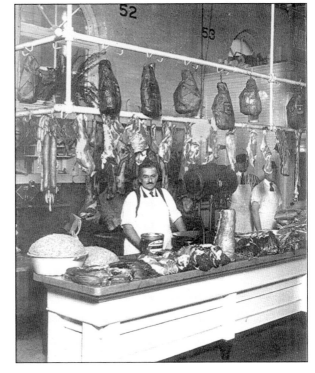

A meat vendor inside the market house posed for this photo. When the market was rebuilt, butchering animals ended in the market house. Prior to that year, the stalls inside were painted dark red to help cover the blood stains from the butchers' stalls.

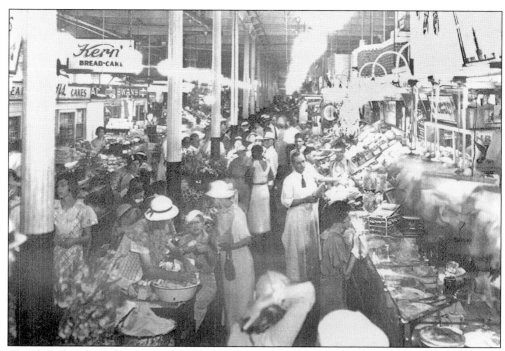

The daily hustle and bustle inside the Market House is seen here as vendors and customers are almost shoulder-to-shoulder. Many of the shingles seen in the photo show well-established companies in Knoxville. The stall owners also bought from local planters, ranchers, and fishermen and many had working contracts with the region's farmers.

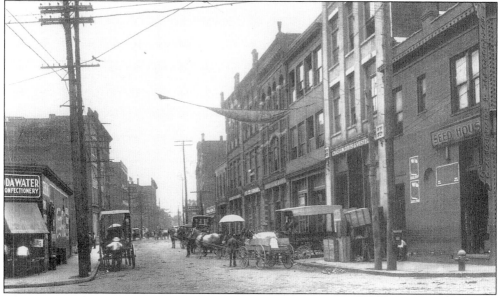

This c. 1910 view, looking east on Jackson Avenue where wholesale houses and agricultural products were available. It was a vibrant business section of the community and did considerable trade. It fell into disrepair over the years as companies ceased to exist, but renovation of many of the buildings seen here has turned the street into what is known as the "Old City" and is now a hot spot of after-hours entertainment and downtown nightclubs.

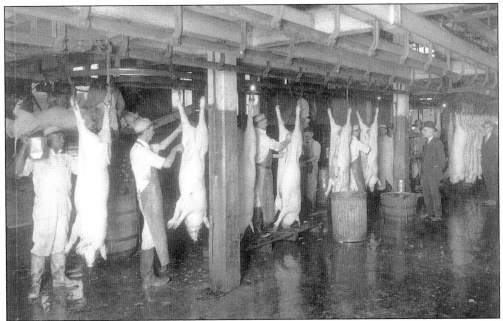

After butchering ceased in the Market House, the T.L. Lay Company opened a butchery downtown on Jackson Avenue. They bought all of their livestock from local ranchers, who provided a steady stream of meat products. The gentleman in the suit is T.L "Boss" Lay, who built Lay's Packing Company into one of the southeast's largest meat packing companies. The photo above shows the slaughtering of pigs from local farmers and the photo below the slaughtering of beef. The T.L. Lay Company provided wholesale products to merchants in a 200-square-mile area and supplied merchants operating in Knoxville's market house.

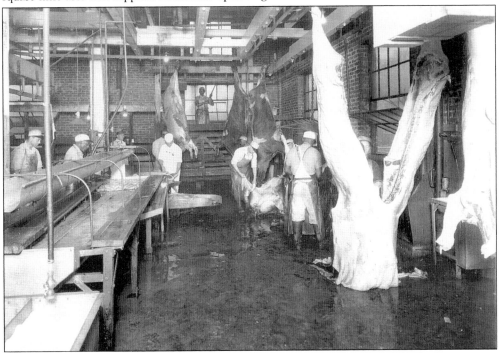

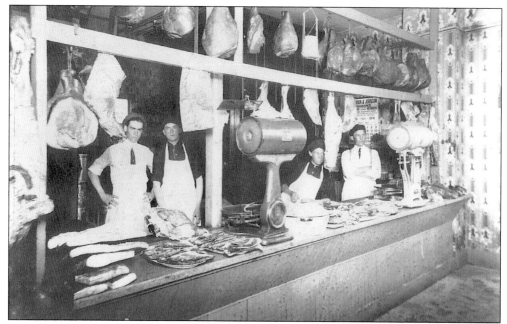

In addition to their massive wholesale operations, the T.L. Lay Company also operated its own small meat store on Jackson Avenue. This photo, taken in 1913, shows a variety of food products available. When the company first went into operation, Lay smoked hams on his farm for consumers, but consumer demand for Lay's smoked hams led to him installing a smoker operation in the plant to keep up with it.

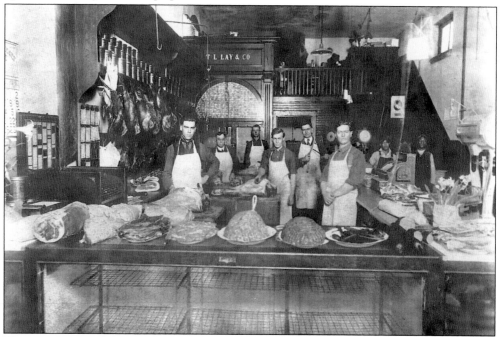

This is a picture of the store taken five years later and shows the butchers who often worked 12-hour days to keep up with orders. Lay's Packing remained a fixture in the city's downtown business district for years and was the only downtown slaughterhouse.

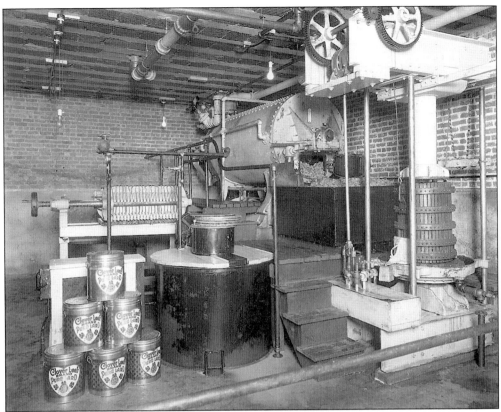

Lay's Packing Company used every part of the animals they slaughtered and were also large suppliers of cooking lard. This photo shows the machine used in the manufacturing of the trademark "Cloverleaf" brand lard that was a fixture in many southern homes.

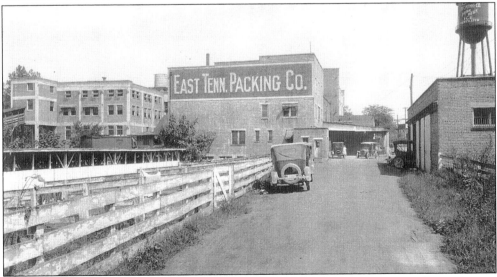

East Tennessee Packing Company, which was operated away from downtown on Sevier Avenue in South Knoxville, was also a butchering house and meat supplier to numerous wholesalers in the region.

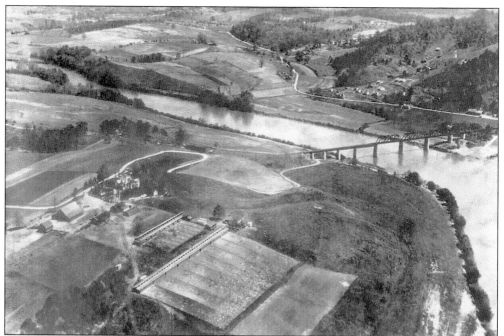

This is an aerial photo taken in the 1930s of another prominent farming operation in Knox County known as Weigel's farms. The massive dairy farm and crop operations would lead to the family founding a chain of Weigel's Convenience stores, which sold their farm products throughout Knox and surrounding counties. The family enjoyed tremendous success and expanded their operations throughout the state of Tennessee.

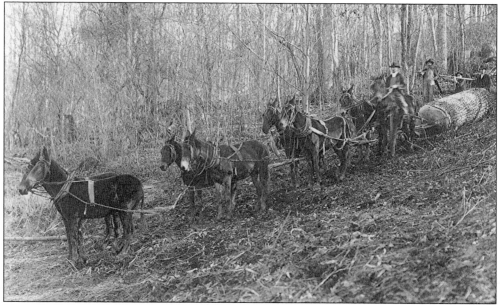

Timber from the Smoky Mountain region of East Tennessee was one of the region's biggest exports. Mountain families made their living working in the logging camps. This photo shows an eight-mule team pulling a log down to the railroad where it was shipped to Vestal Lumber Company in South Knoxville.

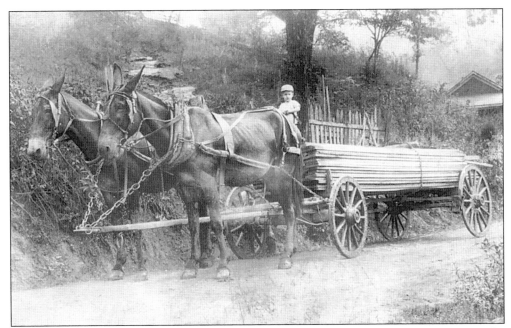

This photo of a young boy hauling lumber on a wagon shows the size of the Tennessee mules needed to pull the loads of timber. Because of the treacherous terrain of the Smoky Mountains, trucks were all but useless.

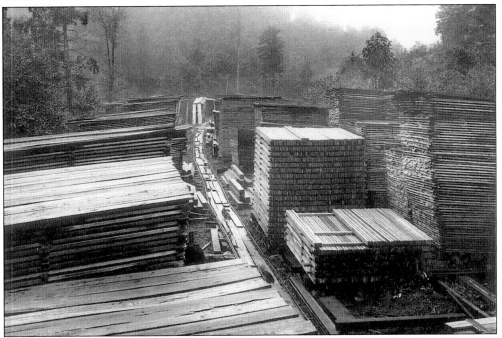

Over the years, tons of hardwood lumber were taken from the surrounding East Tennessee counties for shipment to cities across the nation, as well as Knoxville. The timber industry in Knoxville at one time led to it being called the "Hardwood Mantle Capital of the World," when Knoxvillian C.B. Atkin started exporting his hardwood mantles to some world's most exclusive clientele. The venture made him one of Knoxville's first millionaires.

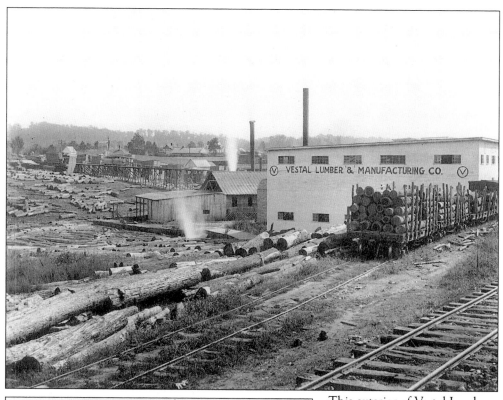

This exterior of Vestal Lumber and Manufacturing Company shows the massive amounts of timber that were brought in by railroad from the Smoky Mountains and East Tennessee. The railroad operation between the Smoky Mountains and Knoxville was discontinued when the region became a national park.

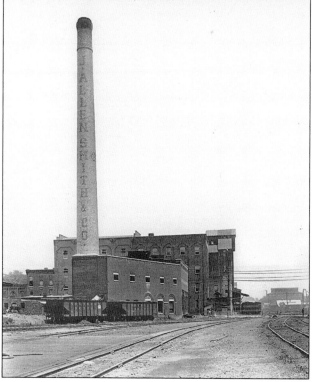

J. Allen Smith came to Knoxville to establish a grain business in 1873. He added a small mill and eventually founded Knoxville City Mills, which he later reorganized under the name of J. Allen Smith and Company.

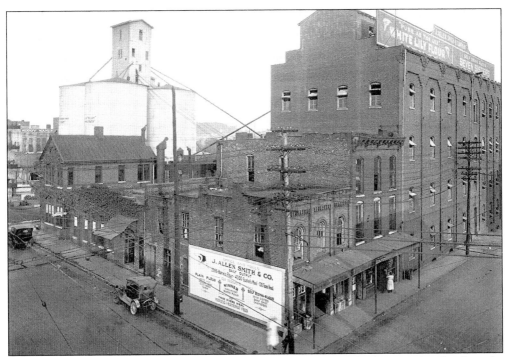

The company Smith founded eventually developed into one of the largest of its kind in the South, producing a number of commercial flours that were highly sought after by bakers.

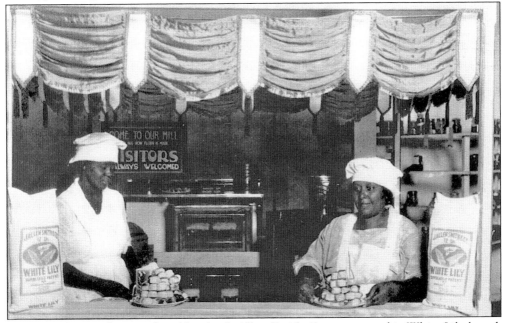

The most famous flour produced by the J. Allen Smith Company was his White Lily brand, named after his wife Mrs. Lillie Powell Smith. This photograph of two J. Allen Smith employees promoting White Lily Flour and offering free biscuits also touted tours of the company. Today White Lily is commonly available in the South, but it can only be purchased in gourmet baking shops elsewhere in the United States.

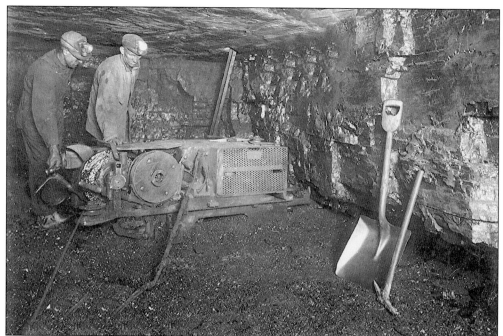

Knoxville also became a major headquarters to numerous coal-mining operations early in its history. In 1892, more than 15 coal companies were based in the city. This photograph shows two coal miners in the Coal Cutting Room in nearby Campbell County. Coal mines could be found in nearly every county in East Tennessee in the late 19th and early 20th centuries.

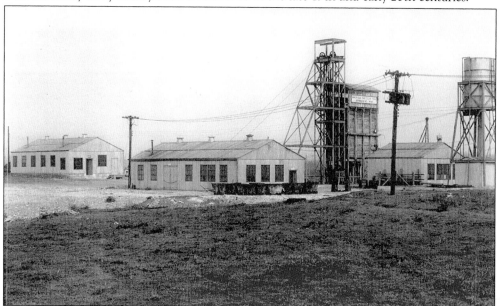

The "worthless metal ore" Hernando de Soto's scouting party reported in their 1540 trek through the region was zinc, and Knox County became one of the principal miners of the ore in the United States. This photo, taken in the 1930s, shows American Zinc Company's Jarnagin Number One Mine in Mascot. The Mascot community is Knox County's principal mining center.

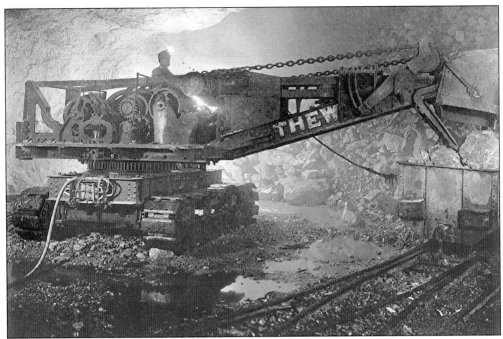

Zinc miners were a hardy lot whose working conditions and hours were like any other miner's. Many had been farmers prior to the development of zinc mining in the early 20th century. The top photograph shows an unidentified miner on a thew shovel loading the raw ore into boxcars on the rail track that led deep within the mine. The bottom image is a miner, also unidentified, taking the load of ore to the processing plant where it was then separated and refined.

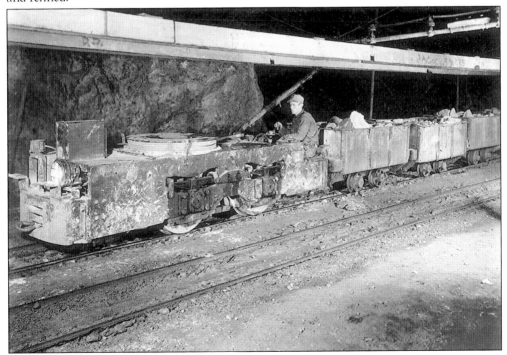

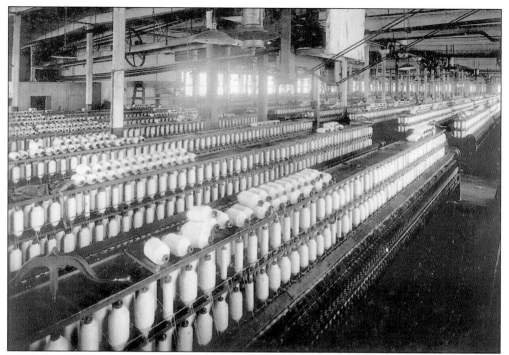

While East Tennessee was not a major cotton-producing area in the South, the city did become one of the largest textile manufacturing cities in the region as wholesale houses declined in the city. This 1917 photograph of the Knoxville Cotton Mills shows rolls of cotton ready to be woven into fabrics.

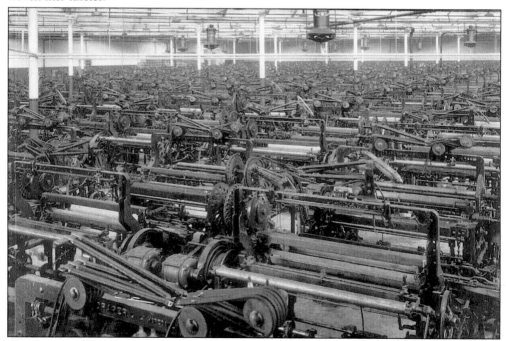

This photograph of Brookside Mills shows the first half view of the weave room with the looms running. The company was one of the largest of its kind in the South.

The textile and clothing industry was Knoxville's largest employer by the 1930s. The job opportunities available in this industry triggered a heavy migration into the city, as did the displacement of thousands of families by the arrival of the Tennessee Valley Authority and the hydroelectric dam projects begun during the Great Depression. The top photo of Appalachian Mills and that of Holston Manufacturing below show how large the factories were and the massive daily production of the companies, including the companies' required switch-tracks so rail cars could be loaded and unloaded.

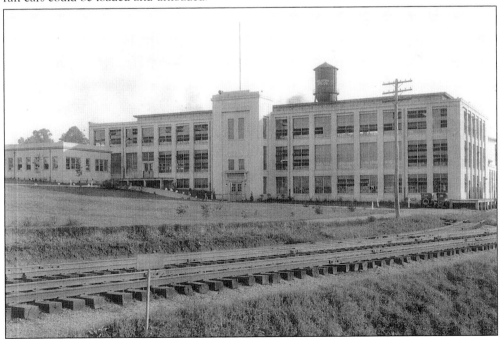

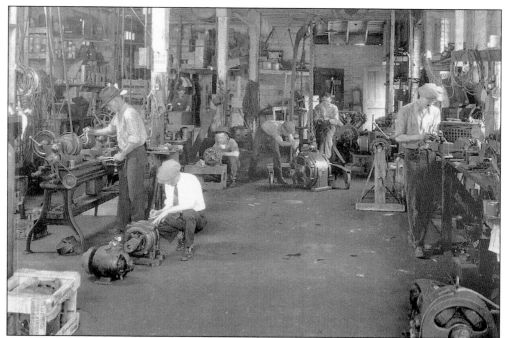

The industrialization of Knoxville and its reliance on electric motors for factory machines saw Tennessee Armature Works practically corner the market in the city in the 1920s and 1930s. The company's employees were full-service repairmen and worked on every conceivable type of motor needed in a variety of manufacturing industries.

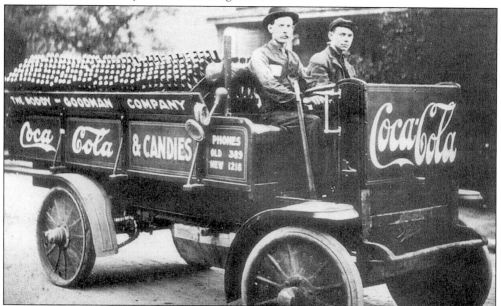

This 1909 "Rapid" was the first truck in Knox County. J. Patrick Roddy and William H. Goodman bought it to advertise their new soft drink and candy company. The candy company, which the two founded in 1902, kept the company alive while Roddy promoted the new soft drink. By 1915, the soft drink business boomed and J. Patrick Roddy and Goodman split up. Roddy remained in the city and Goodman went west to start a candy company in Denver.

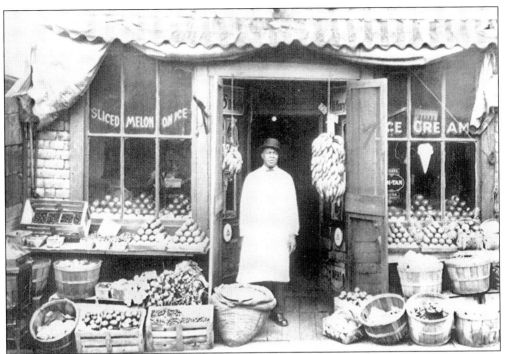

In the late 19th and early 20th centuries, numerous black-owned businesses were flourishing in Knoxville. This photo, taken around the turn of the century, shows Sylvester McBee outside his popular fruit stand on East Vine Street.

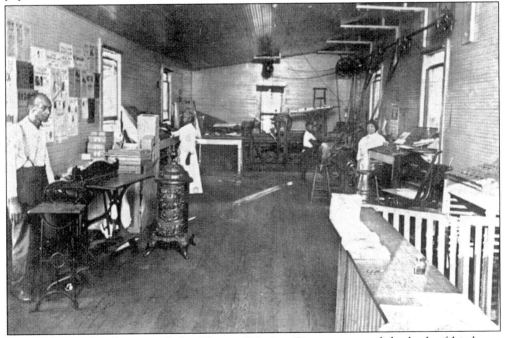

Noah Gleaner Smith operated the Gleaner Printing Company out of the back of his home on Vine Avenue. He founded the company in 1902 and it stayed in continuous operation for 50 years.

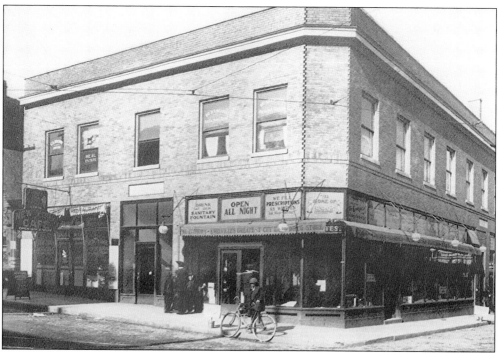

Former slave Calvin F. Johnson owned the "Cal Johnson" building at the corner of Vine and Central Avenues and numerous other businesses throughout the city, including Knoxville's only horseracing track and many restaurants and nightclubs frequented by all Knoxvillians. In 1883, he was elected as Knoxville's first black alderman.

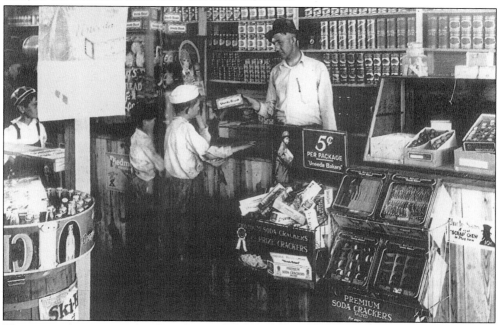

This scene depicts a Knoxville grocery market in the 1920s. Like most it sold canned and prepackaged food. It was not until the 1930s that the Atlantic and Pacific Tea Company opened the first modern-day grocery store in the city.

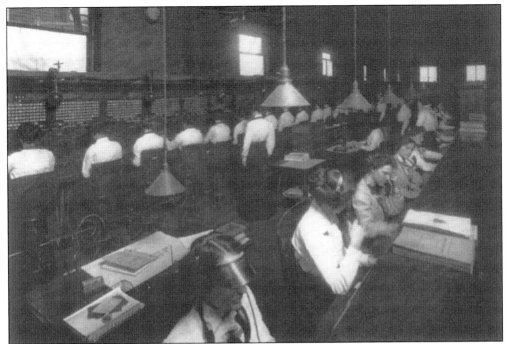

This interior image of telephone operators in the Cumberland Telephone Company (c. 1913) shows operators working while a supervisor paces behind them. The telephone company was later purchased and folded into South Central Bell.

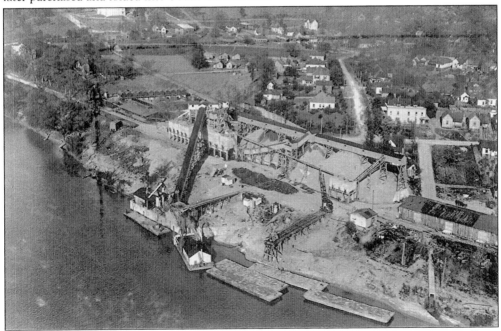

Mining operations like the sand and gravel companies located along the Tennessee River continued to use the river to move its products downstream. This aerial photo shows the size of one company's development of a commercial waterfront necessary to mine sand and gravel from the riverbanks.

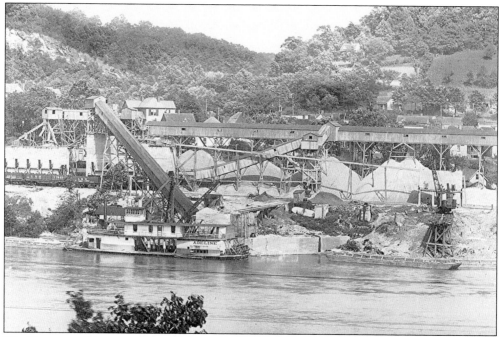

The Tennessee River as a transportation artery has never reached its full potential and has led to the use of government funds since the mid-19th century to develop it. Freight costs to ship such heavy items as sand, gravel, salt, and other mining products by rail was too prohibitive. Seen here is the flat-bottomed paddlewheel riverboat *Adeline*, which was used in later years to haul sand and gravel downstream.

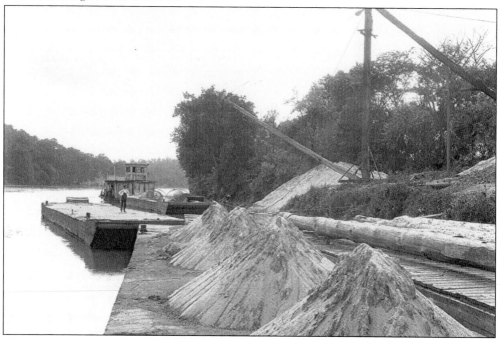

This shows one method used on the Tennessee River to haul sand. Barges were loaded and then hooked to the side of a river tug and pulled downstream.

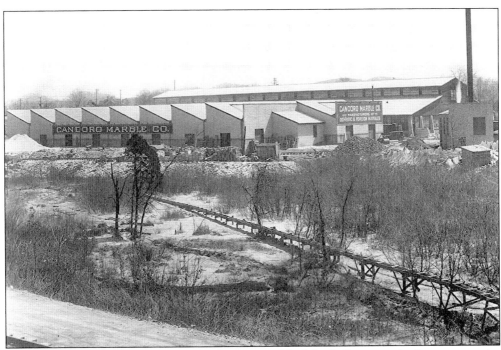

There was no greater industry in Knoxville than marble. John J. Craig was the first to recognize the potential of marble in Knox County and formed the city's first marble company. The company passed through the family, and, upon the death of his son John Craig Jr., fell into the hands of John Craig III. He reorganized the marble interests of his family and created the Candoro Marble Company to saw and finish the marble mined from the quarries they owned in the tri-county region.

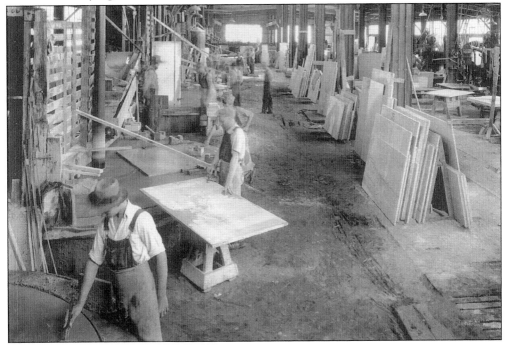

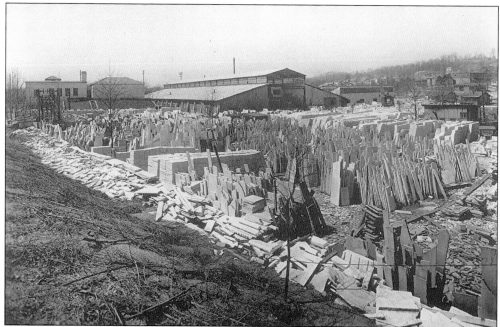

Marble from East Tennessee was so highly regarded by builders and architects that it was used in the Smithsonian's Museum of History and Technology, the American Federation of Labor-Congress of Industrial Organization's (AFL-CIO) National Headquarters, Australian Chancery, and the largest marble building in the world—the National Gallery of Art.

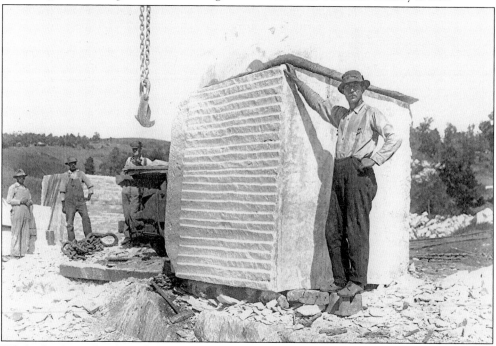

While the Craig family and the Candoro Marble Company were the most noted, there were numerous companies that quarried marble. This photo taken in 1916 shows a six-by-six-foot piece of marble that was lifted and readied to be shipped, sliced, and polished.

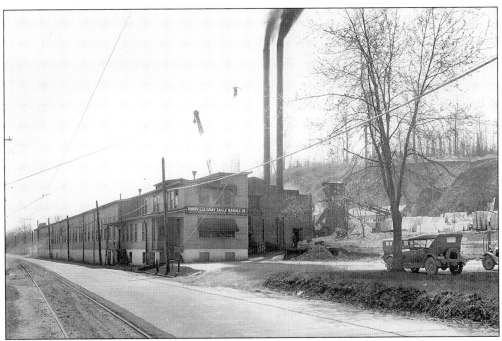

The Knoxville Gray Marble Company was another major quarrier of marble in the city. The Gray Knox Number One Quarry, seen below, illustrates the scale of Knoxville's marble operations. Marble builders brought in from overseas preferred the Tennessee marble to any other in the nation and led to Knoxville being regarded as the marble capital of the United States in the early 20th century.

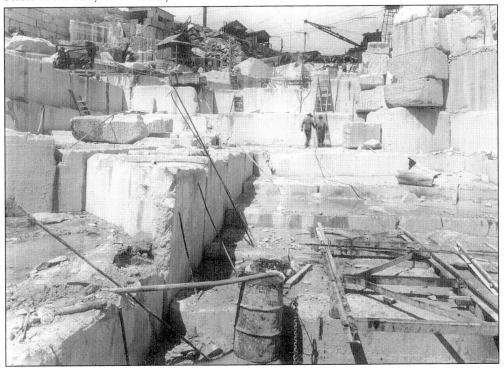

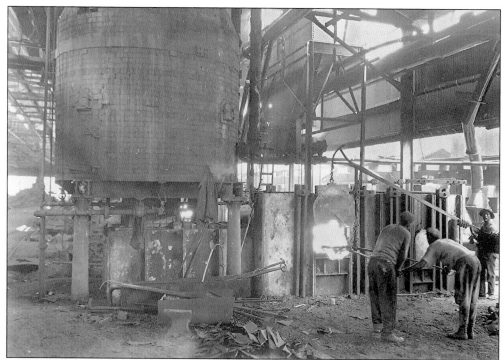

This scene is of the "puddling furnace" at Knoxville Iron Works. The company started just after the Civil War as a collector of scrap iron. They melted iron into reusable forms to be sold to processing companies for use in manufacturing.

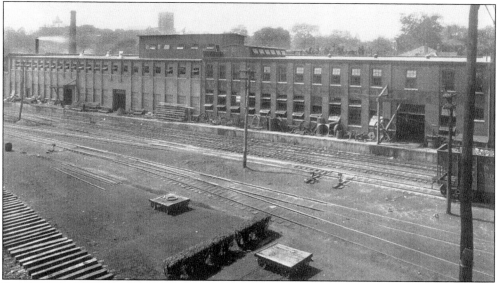

British citizen William James Savage was a millwright who moved to Knoxville in 1884 to install flourmill machinery for J. Allen Smith and who decided to stay in the area. He started his own business one year later, manufacturing flourmill and marble mill machinery. The W.J. Savage Company became a leader in its field and patented numerous manufactured products. The company remained under his leadership until his retirement in 1929, when it was sold to Weston M. Fulton.

Three

THE "CAN DO" COMPANY

Weston Fulton first moved to Knoxville in 1897 as a meteorologist assigned to the newly created weather bureau in the city. At the request of the University of Tennessee, he moved the bureau to the "Hill" on campus. Fulton's one objective as a meteorologist was to find a way to measure the fluctuating Tennessee River. In those days, massive flooding was not uncommon and being able to detect early rises in water levels from mountain rains could help save lives. Fulton's efforts resulted in him devising an automatic river gauge that caught the attention of those in his industry and became the subject of a special government bulletin.

The discovery of new power sources in the late 1900s promised a phenomenal age in industry, but Fulton knew before the goal could be realized there had to be a way to harness and control energy. He sensed he was on to something with his river gauge and began work on the project in the University of Tennessee laboratories. The end result was a seamless metal accordion-like bellows device.

In 1904, Fulton formed the Fulton Company in Knoxville. Through the years, the Fulton Company has cultivated an employee base so loyal to the traditions of its founder that it is unlike any in the nation. Fulton and his employees' perseverance led to the greatest industrial revolution in American history. It was their ingenuity and innovative engineering that often brought government officials to them with problems that needed solving and earned Fulton's business the nickname: "The Can Do Company."

Weston M. Fulton was a prolific inventor who loved to spend his spare time making toys for his children using his devices. He was also a major leader in civic affairs in the city and was elected vice mayor of Knoxville in 1923.

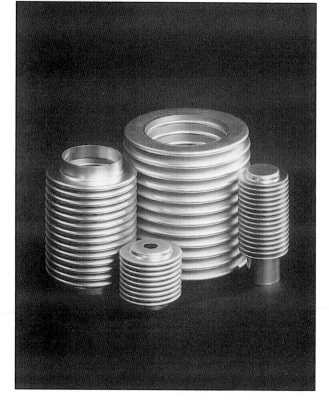

The "sylphon" seamless metal bellows invented and perfected as a thermostatic regulator allowed Fulton to incorporate it into numerous other inventions. In fact, so many new devices evolved from it that the United States Patent Office was forced to create a special section to house his inventions.

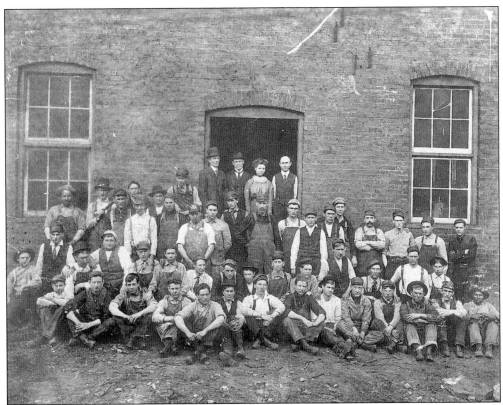

This is a photograph taken in 1910 of the original Fulton Company plant located on White Avenue and the company's first employees.

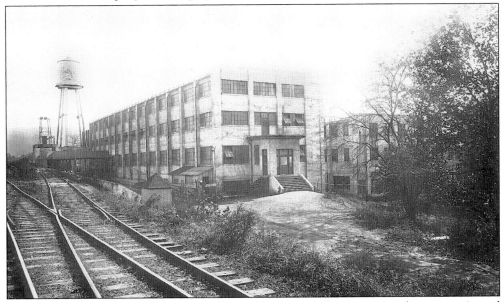

The Fulton Company's growth in Knoxville was phenomenal, thus increasing the company's need for power and compressed air. Weston Fulton moved to the new location on Cumberland Avenue in 1917 and devised underground systems where the company produced its own power.

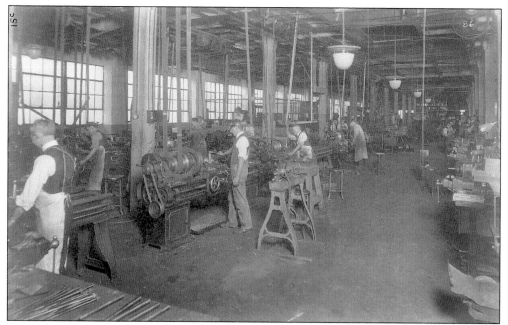

The Fulton Company's technology was so progressed that a tool room had to be created where engineers could make the special equipment needed to build their inventions. In World War I, the Fulton Company gained international prominence by adapting its bellows device to depth bombs for the United States Navy, allowing more precise detonation over the targets—a device credited by the Navy for allowing them to retake the Atlantic from the Germans.

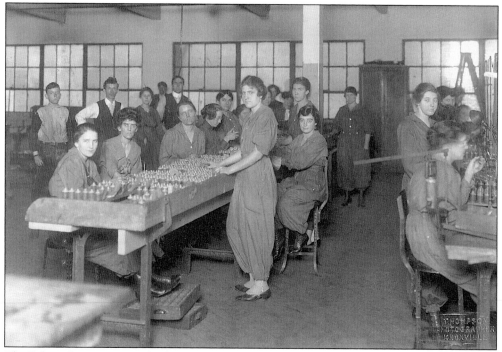

The Fulton Company was a leader in Knoxville when it came to hiring women for the workforce where they served in a variety of positions.

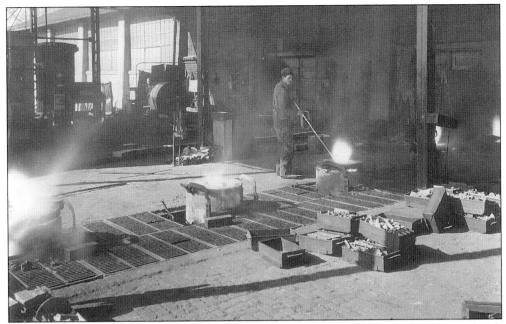

This shows the brass-melting furnace in the company, which is heated by crude oil mixed with air. The sylphon bellows are made from a flat sheet of special brass that begins its journey in the forge.

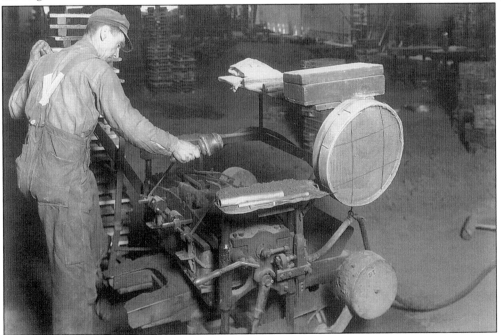

This is a scene from the brass foundry where molding was done. Compressed air played an important part in the process. The pattern was wrapped out by a vibrator, which allowed it to be removed from the molding sand without harming the impression. In World War II, more equipment was added to start production of brass casings for artillery shells, producing more than 44 million shell fuse assemblies.

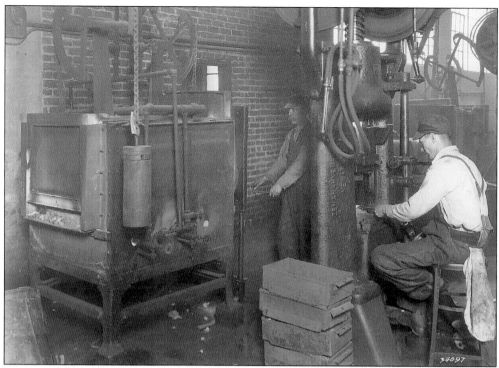

This forging department view shows one of the company's many forging machines. The parts made here are used for thermostat heads and other devices.

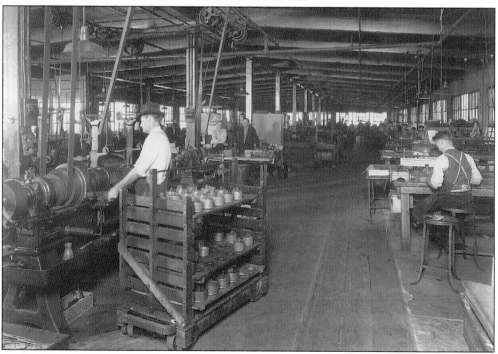

In the assembling department, bellows were fitted with heads and tested for possible leaks in the manufacturing process.

This scene shows the press room where small thermostat parts were made. The Ingersoll-Rand compressor just behind the press was used in emergencies only. Fulton's company was completely self-sufficient in producing its own compressed air to the levels that it needed.

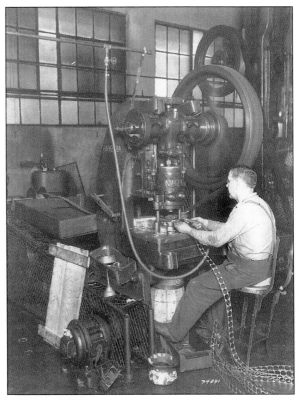

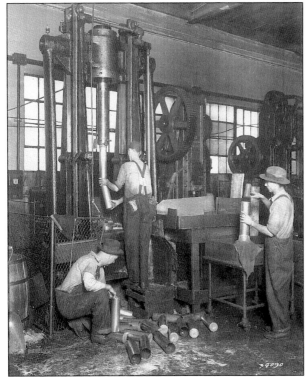

These men are working in the press department making large sylphon tubes being formed on punch presses.

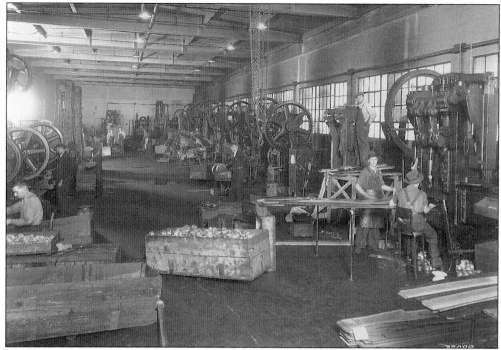

In making a bellows, the first operation consists of drawing the flat flask into a cup. Succeeding steps lengthen the cup, reduce the thickness, and roll it into a bellows. The sylphon tubes are then removed from the punches.

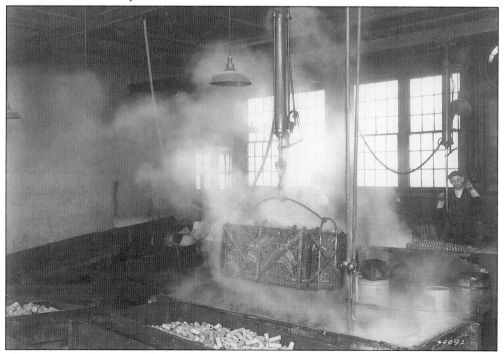

This is an annealing room where all the sylphon tubes are heated and then slowly cooled before being dropped into a cleaning solution to remove all dirt and scale from the tubes.

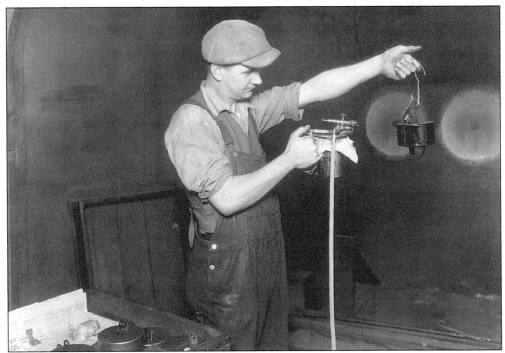

Regulators are painted in the paint shop. Here, the operation is painting a damper regulator with an airbrush.

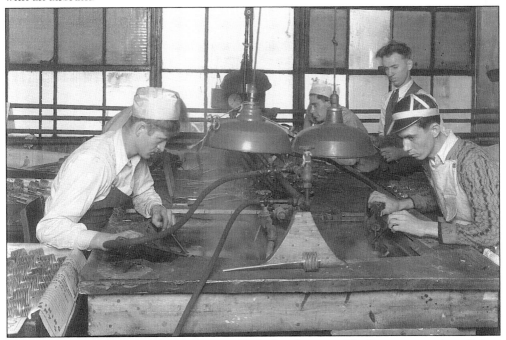

Employees test sylphon thermostats for possible leaks after assembly. During peacetime, Fulton Sylphon products were revolutionizing American industries and enjoying phenomenal growth as a company. Weston Fulton sold the company in 1930 and devoted his attention to the W.J. Savage Company, which he had purchased and was producing some of his other inventions.

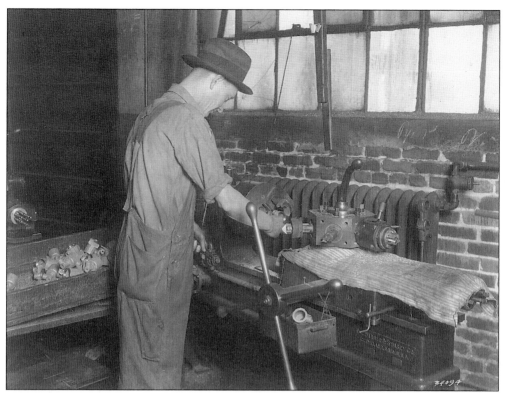

One of the most important departments in the company was the machine shop. The photo above shows thermostat parts during machining operations and an air chuck being used as a holding valve. The image below shows turret lathes equipped with automatic air chucks.

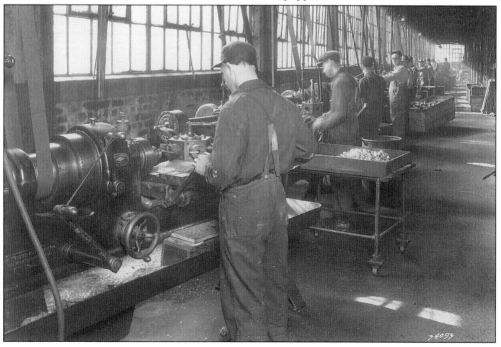

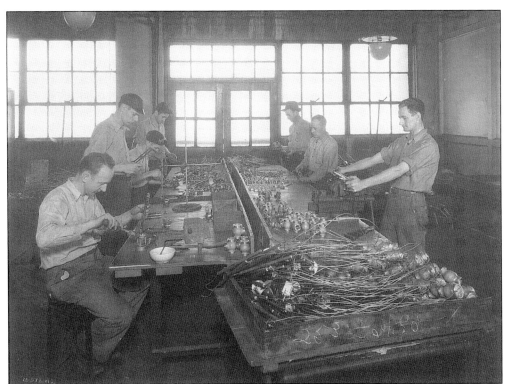

The Fulton Sylphon Company was one of Knoxville's largest employers in the years leading up to and during World War II. Among its accomplishments, other than brass cartridge production, was the development of numerous regulating devices for the military. It was said "a metal bellow was an essential part of everything that rolls, floats, shoots or flies."

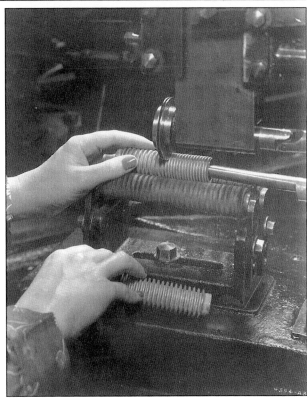

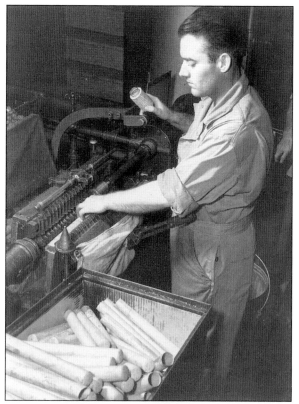

During World War II, the military contracts for the Fulton Sylphon Company, which was then a part of Robertshaw Controls, were phenomenal and the company continued to grow. Many top-secret projects were manufactured at the plant and the railroad behind it was a key method of maintaining national security. The company produced over 50 percent of the computer unit for a top-secret English bomb site and, between the Fulton Sylphon Company and the W.J. Savage Company, then under the leadership of Weston Fulton, contributed elements to the classified project. The photo below shows the variance in size of the bellows manufactured in the company, which also called upon for use in the Manhattan Project, then occurring in nearby Oak Ridge, during World War II.

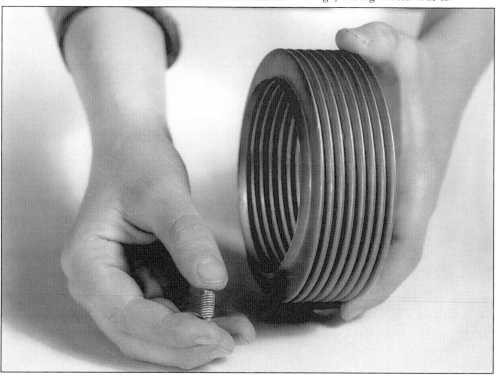

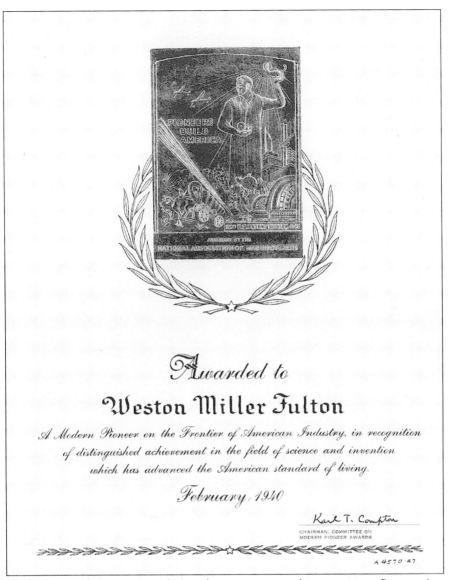

Awarded to

Weston Miller Fulton

A Modern Pioneer on the Frontier of American Industry, in recognition of distinguished achievement in the field of science and invention which has advanced the American standard of living.

February, 1940

Karl T. Compton

CHAIRMAN, COMMITTEE ON
MODERN PIONEER AWARDS

A 4570 A7

In 1940, the National Association of Manufacturers presented its prestigious Pioneer Award to Weston Fulton recognizing him for his career as an inventor.

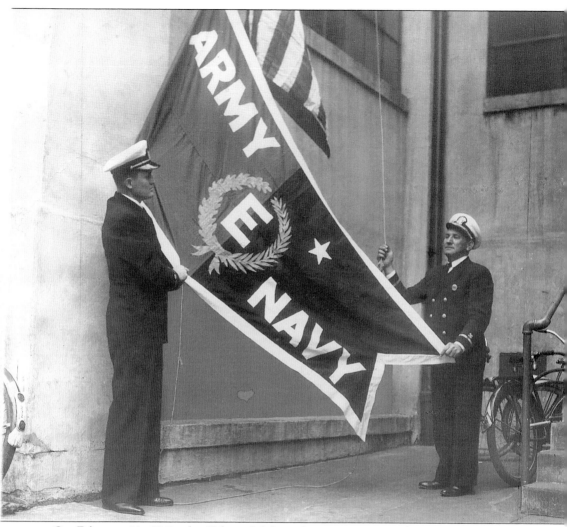

On February 14, 1942, the Fulton Sylphon Company was number 55 out of more than 10,000 eligible suppliers to receive the prestigious Navy "E" award for Excellence in Performance. As seen here, eight months later the company was awarded the Army/Navy "E" with five stars—the maximum number awarded to industry—for their outstanding production in the war. In 1945, President Franklin D. Roosevelt personally awarded Fulton with a Presidential declaration.

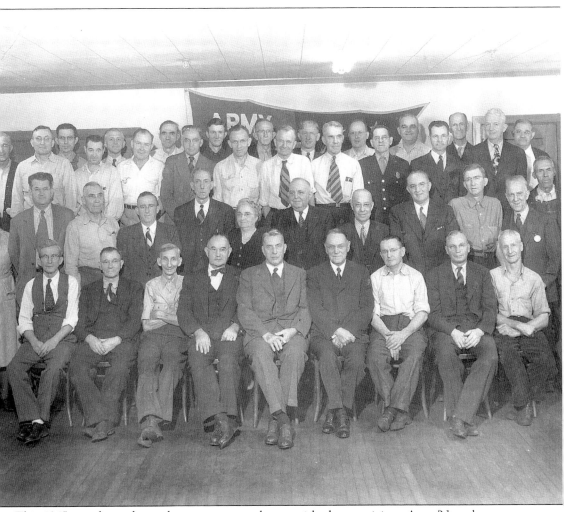

This 1945-era photo shows the company employees with the prestigious Army/Navy banner behind them.

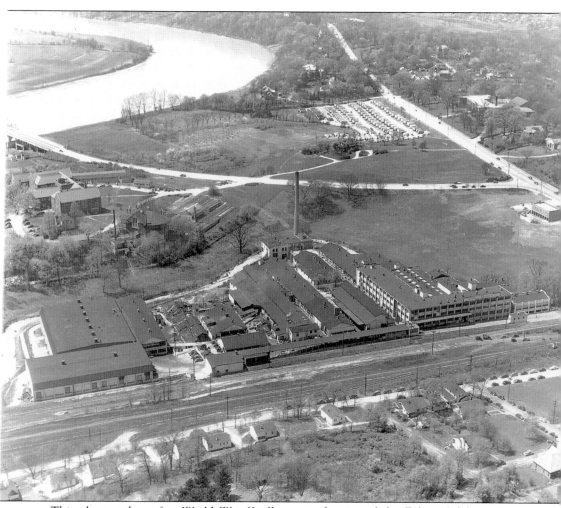

This photo, taken after World War II, illustrates the size of the Fulton Sylphon Company and shows the massive expansion of the company. The company continues their pursuit of excellence and the regulating device invented there is still spawning patents. From the first submerged submarine-fired missile, to nuclear power regulation, to the Saturn, Mercury, Apollo, and space shuttle missions of today, it is still regarded as one of the most innovative manufacturing companies in the United States.

Four

PLANES, TRAINS, AND AUTOMOBILES

Knoxville was like many Southern cities in the development and evolution of transportation. Because of its nearness to the mountains, however, the horse remained a vital part of transportation for many families well into the 1940s.

The Tennessee River was never a major means of passenger transport because of Muscle Shoals and its unnavigable waters. A couple of passenger steamboats tried to establish service with much celebration, but they never truly succeeded as much as the freight bargers did, who travelled it continuously.

On July 4, 1836, 400 delegates from 9 states met in Knoxville's First Methodist Church to start work on a railroad system that would take 19 years to the day to complete. In 1858, a number of rail companies had started up in or near the city. Passenger service still was not as lucrative as cargo, which was beginning to do a booming business before the outbreak of the Civil War. They resumed operations afterwards, but, by the 1920s, Southern and the L&N Railroads controlled the city's tracks.

Roads and highways were also under construction across the region in the 1920s and automobiles were becoming the chief method of transportation. However, it was the streetcars that still ruled downtown and were Knoxville's only real success with mass transit.

Airline service was slow in coming to the city as well, but leaders saw the potential of it and, unlike their colleagues in the past, took an active part in developing it and making airline service a vital part of the city's future.

When the great interstate projects began in the 1950s, Knoxville boomed. Two major interstate routes eventually converged in the city attracting new businesses and making the established ones more reliant on long-haul trucking than trains to move their products.

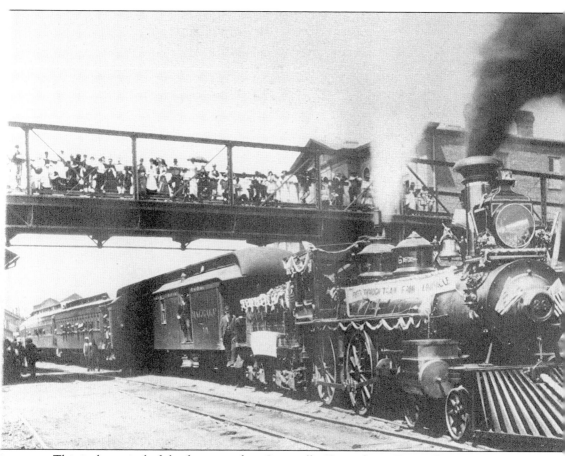

This is the arrival of the first train from Louisville, Kentucky to Knoxville on June 3, 1883 to much fanfare and celebration. The completion of the direct route took many years and opened the American Midwest to Knoxville for the first time.

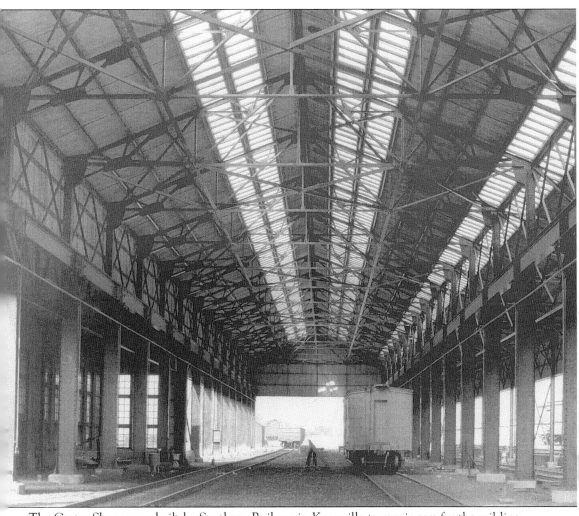

The Coster Shops were built by Southern Railway in Knoxville to repair cars for the rail line. When passenger transportation ended in 1970, the need for the shops began diminishing and they were eventually abandoned.

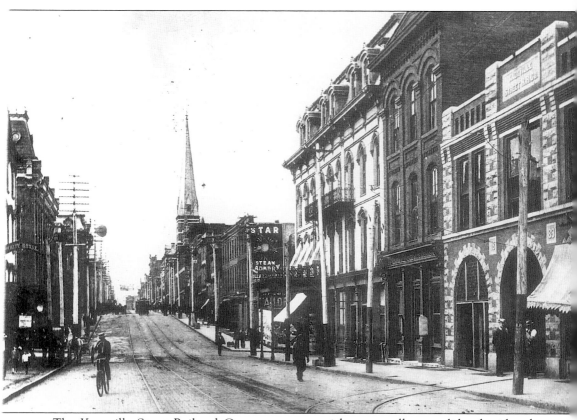

The Knoxville Street Railroad Company seen at right eventually consolidated with other streetcar services to form one unified system. The electric streetcar system in Knoxville was impressive with more than 53 miles of tracks laid.

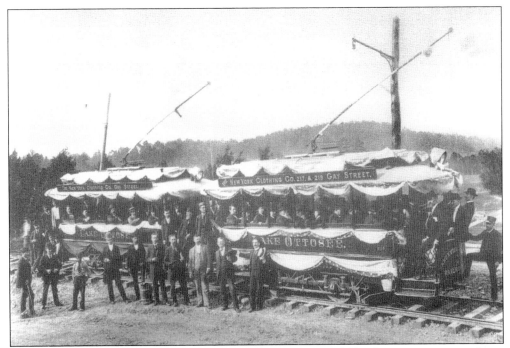

The first electric streetcar debuted in Knoxville on May 1, 1890, when a procession of cars carried leading citizens from Gay Street to Lake Ottosee in East Knoxville.

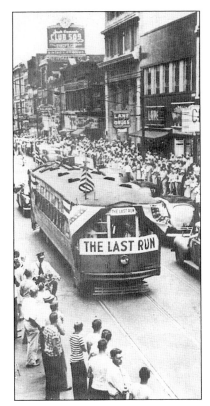

The last electric streetcar on Knoxville streets made its final run on August 1, 1947. It was replaced with fuel-powered buses. The city transit system has never enjoyed the success it once had and, as the city expanded, could not afford to keep pace with residential development.

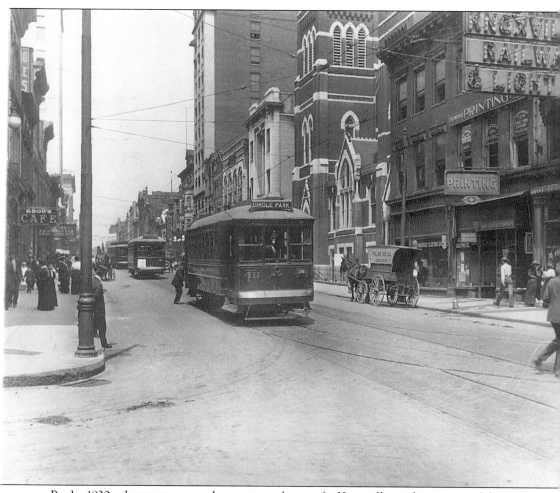

By the 1930s, the streetcar was the most popular way for Knoxville residents to travel downtown. It was cheap and efficient and the city's only successful experiment with mass transit. Later in the decade, however, passenger service began falling off and Knoxville eventually decided to do away with it.

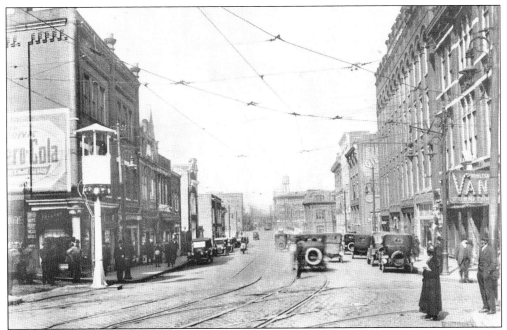

As the automobile became the popular mode of transportation for Knoxvillians, traffic problems and congestion were relieved by traffic signals located on the police towers seen at left. The officer inside the tower would change the lights based on his view from the box to keep traffic flowing smoothly.

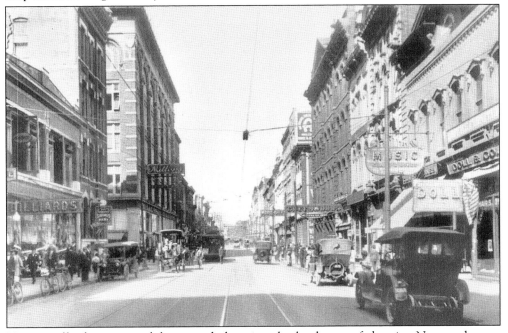

Heavy traffic from automobiles started changing the landscape of the city. New roads were needed to help take the pressure off Gay Street, which was too small to accommodate the growing traffic problems, as the Gay Street Bridge was still the only road across the Tennessee River from the south end of the city.

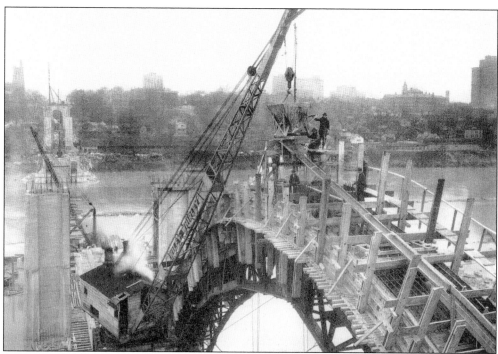

In 1931, work began on the Henley Street Bridge over the Tennessee River giving South Knoxville another connecting bridge. The top photo shows workers pouring the forms for the 186 million pound structure. City leaders were amazed at the speed of the construction. The bridge cost the city's taxpayers $1 million and was built in under a year.

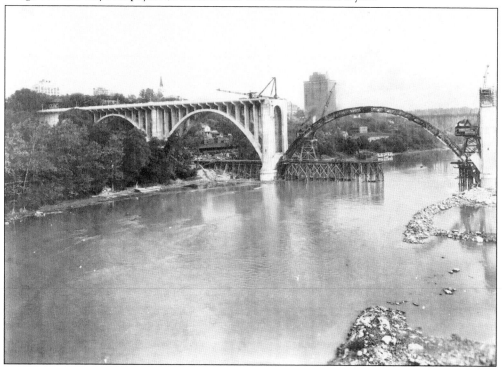

This biplane is sitting on Knoxville's first official airstrip off of Sutherland Avenue. Following World War I, Mrs. Betty McGhee Tyson donated the parcel of land on the promise that the city would forever keep an airfield named "McGhee-Tyson" in honor of her son, World War I Fighter Pilot Charles McGhee Tyson, who was killed overseas.

The grand opening of McGhee-Tyson Airport on October 15, 1937, was not without controversy. Since it was located in nearby Alcoa, the city leaders there had secured passage of a state bill naming it the Great Smoky Mountain Airport, but Knoxville mayor George Dempster fought back and made sure the name McGhee-Tyson remained.

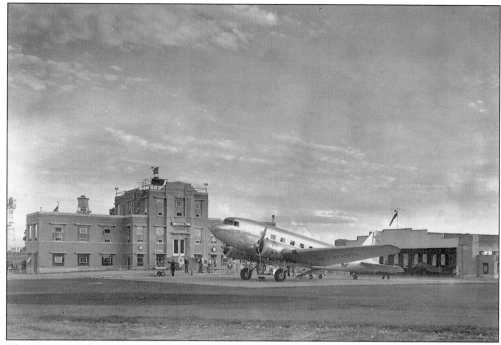

The DC-2 airplane from American Airlines established the city's first national passenger service. The airline had to move its short-lived operations from the Island Home airport located downtown to McGhee-Tyson when it was determined the plane was too large for the Island Home airport.

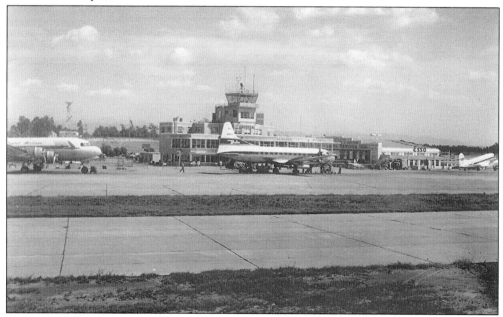

The next airline to arrive in Knoxville was Delta, and it became the largest commercial operator. As with the railroads, passenger service was an important part, but air cargo became the commercial mainstay of airline service to and from the city. Delta still operates in Knoxville today.

Five

TO SERVE AND PROTECT

Knoxvillians have a long tradition of service to their community and nation. The opportunity to serve is seen more as a privilege than a job and some have developed long family traditions of service in the fire, police, and military branches. Police and fire departments were slow to develop in the city, but names of original members can still be found in the ranks of file of the departments, as these careers have become the "family business."

In wartime, it was no different. Prior to the Korean War, when major numbers of troops were needed, the President asked the states' governors to activate their military departments to meet the goals needed by Washington. Knoxville was like any other city in Tennessee in that joining the armed forces is seen as a right of citizenship, and at times, father and sons have enlisted together. Although the city may not be recognized as being as old as others in the United States, the families' longevity in Knoxville and East Tennessee is very much like those in some of the first colonial states. Prior to the territory becoming a state, many early settlers had left their family homes to join the cause of Independence.

It is this tradition of service to the nation that caused Tennessee to earn the "Volunteer" nickname, and it is still a source of pride among Knoxville families who can point to ancestors' service in every major war the United States has fought, from the Revolutionary War to today's conflicts in the Middle East. These family legacies truly deserve their own book and are the reason the nation's armed forces recruiters so highly regard Knoxville and East Tennessee.

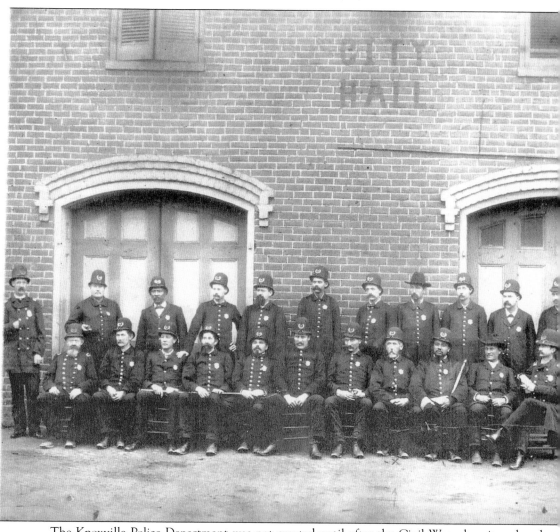

The Knoxville Police Department was not created until after the Civil War when it replaced the town constable. The officers seen here in 1883 outside City Hall performed a variety of tasks, including overseeing the market house to guard against bad merchandise and settle disputes. Of special note in the photograph are the two black officers on the force.

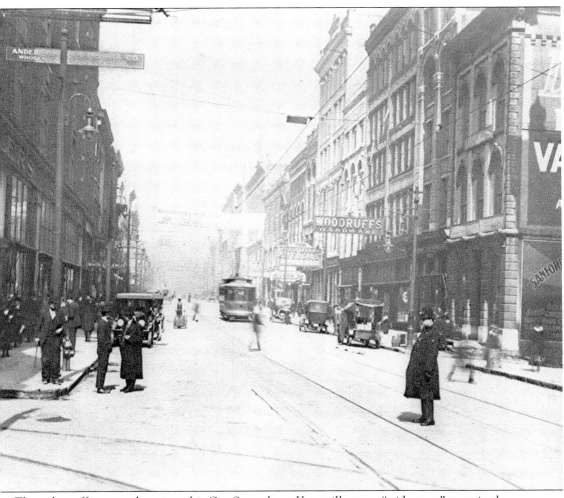

The police officer seen here is on his Gay Street beat. Knoxville was a "wide-open" town in the late 19th and early 20th centuries. The biggest story around this era was the capture of Harvey Logan, also known as Kid Curry, whose capture left two officers critically wounded.

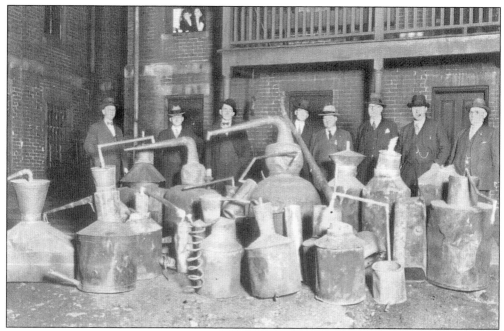

After the prohibition era started in the 1920s, Knox County was a hotbed of illegal liquor trade. This scene is from the Hill Avenue jail in the 1920s; the sheriff is showing off the stills captured from moonshiners. In the upper left, the jailer's family, who lived above the facility, can be seen.

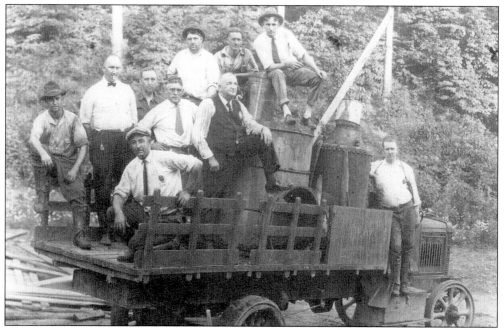

In June 1925, Sheriff Walter Anderson and Prohibition officer West Wynn raided a West Knox County bootlegging operation and seized a 500-gallon still and more than 1,600 gallons of beer. Illegal liquor in the city and region was so prevalent that even Chicago Gangster Al Capone kept a residence in Knoxville.

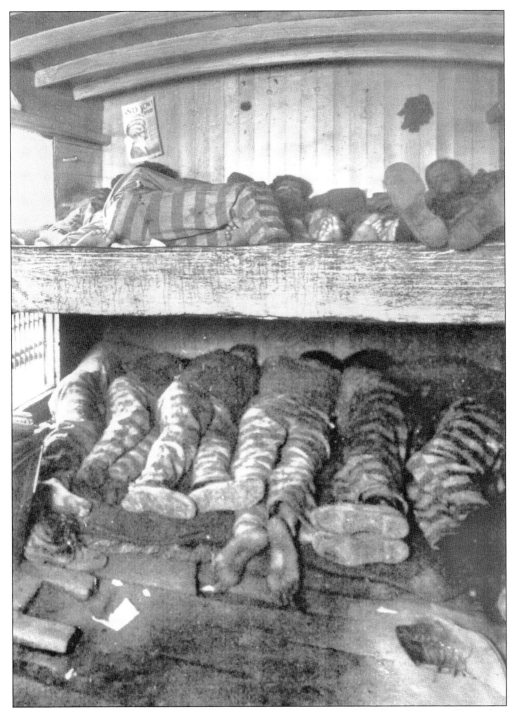

This scene is from the Knox County Workhouse in the 1920s. When this photograph was first published it was denounced by reformers of the workhouse and their outcry led to major changes being implemented to better the conditions of the prisoners.

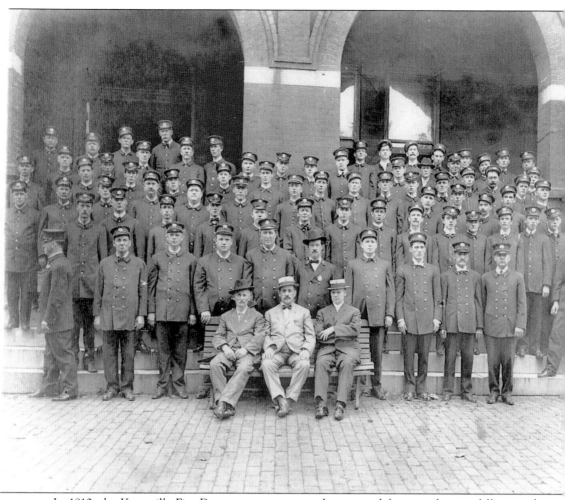

In 1910, the Knoxville Fire Department was a much-respected force in the city following the Gay Street Fire of 1897. Although the first fire company was established in the city in 1822, it was not until March 17, 1885, that the Board of Aldermen created the Knoxville Fire Department and hired the first 15 firemen.

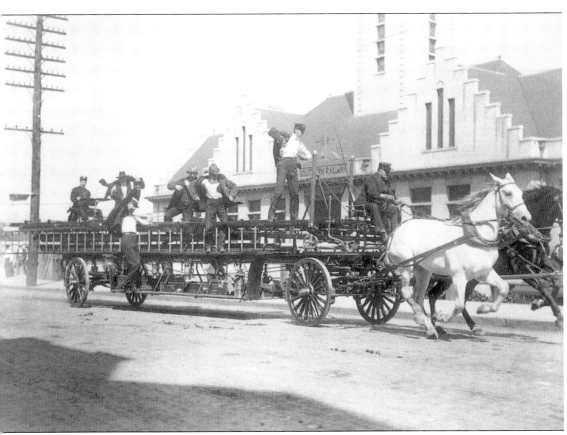

This scene from the early 20th century shows the horse-drawn ladder truck and firemen in action in front of Knoxville's Southern Railway Headquarters. The scene was allegedly staged for the camera to show the efficiency of the company and resolve resident concerns about the fire department's abilities in action.

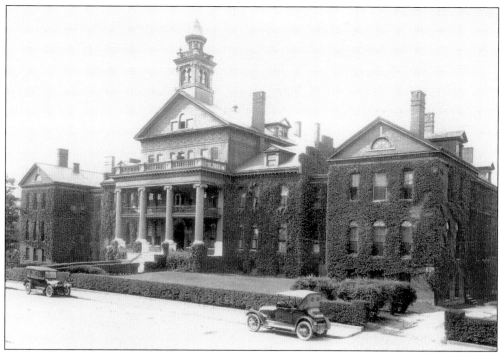

This is Knoxville General Hospital around the 1920s. It was the city's only major medical facility for some time. In 1964, Mrs. Calvin Buehler wrote the book *By Dim and Flaring Light* about Knoxville General Hospital nurse Augusta Tamm and her colorful career at the facility.

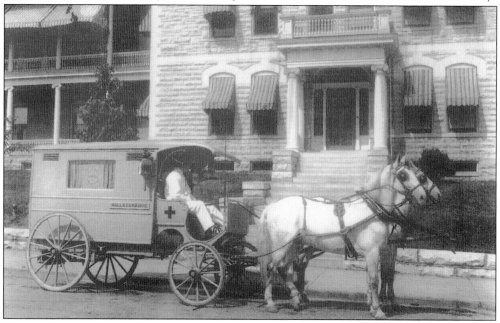

The horse-drawn Hall and Donahue Ambulance waits outside the Lincoln Memorial University Hospital, which sat across the street from Knoxville General Hospital. Lincoln Memorial was also a medical school that fell upon hard financial times and was later acquired by Knoxville General Hospital as an addition to their facility.

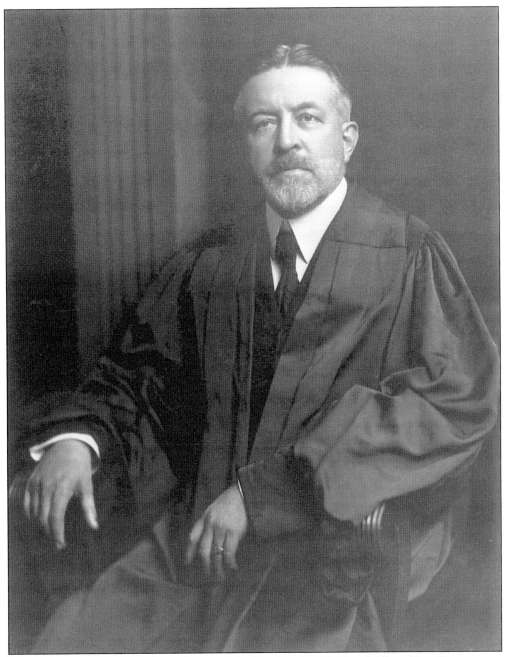

Justice Edward Terry Sanford was the son of the founder of Sanford and Albers Drug Company on Gay Street and was Knoxville's only United States Supreme Court Justice. As an Associate Justice on the Court, he handed down more than 130 rulings during his seven years of service.

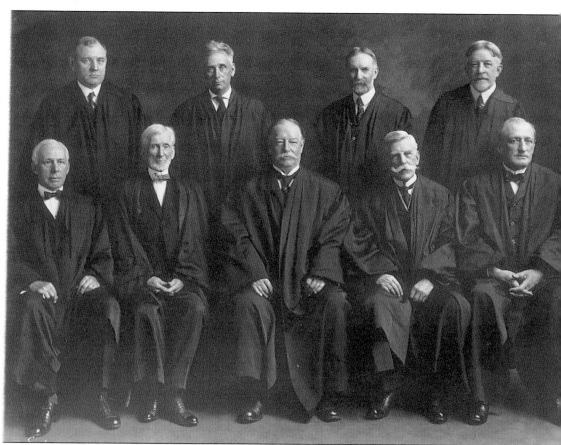

Associate Justice Edward T. Sanford served on the United States Supreme Court under Chief Justice and former President William Howard Taft. Both men died on March 8, 1930. While Sanford was laid to rest in his hometown of Knoxville, President Taft became the first President to be buried in Arlington National Cemetery. Pictured above, from left to right, are (front row) Associate Justice Willis Van Devanter, Associate Justice Joseph McKenna, Chief Justice William H. Taft, Associate Justice Oliver W. Holmes, and Associate Justice James C. Reynolds; (back row) Associate Justice Pierce Butler, Associate Justice Louis Brandeis, Associate Justice George Sutherland, and Associate Justice Edward Sanford.

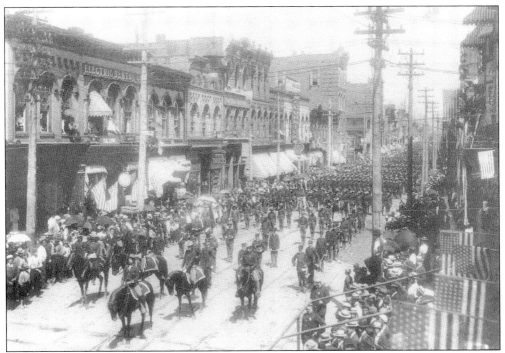

This photograph, taken in 1899, shows the troops returning home from the Spanish-American War in a triumphant parade down Gay Street. The service of the East Tennesseans in both the Philippines and Cuba fighting against Spain was highly praised by their officers. Three of those soldiers received the Medal of Honor for their actions under fire.

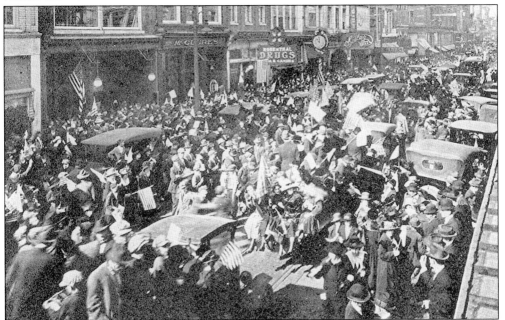

This scene shows Knoxvillians on a crowded Gay Street celebrating the signing of the armistice November 11, 1918, at 11 a.m. The celebration downtown began long before dawn and did not end until well into the night.

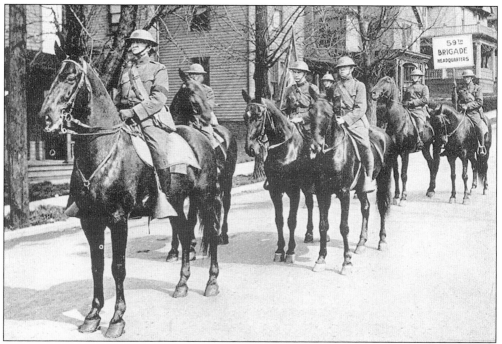

This horse procession is led by Gen. Lawrence D. Tyson, whose son Charles McGhee Tyson, was killed when his plane was shot down over the North Sea. This photograph, taken on April 4, 1919, shows him and his staff before the parade of the 117th Infantry Division down Gay Street.

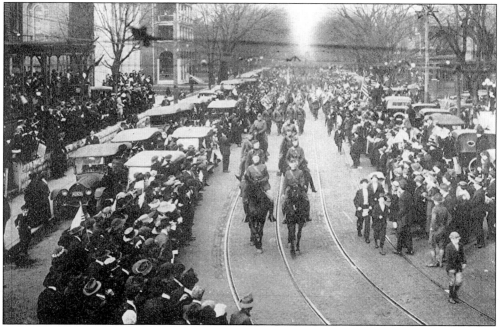

Cols. James Gleason and Luke Lea lead the parade towards Gay Street followed by Battery C of the 117th Infantry Division. The parade was the largest Knoxville's downtown business district had ever seen.

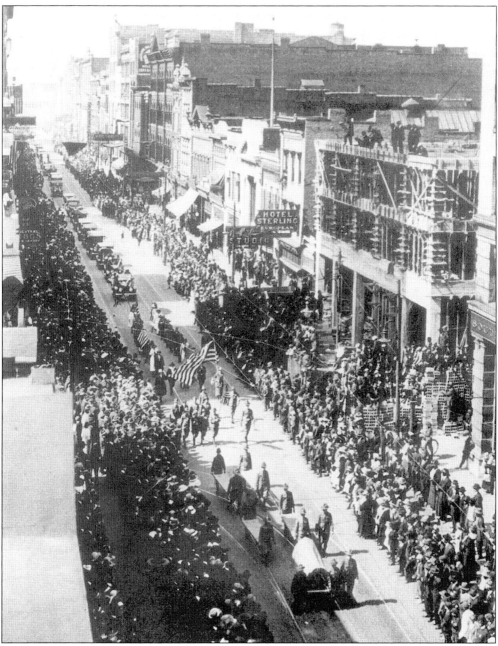

The war effort at home was a continuous undertaking by city leaders and organizations. This parade was held on Gay Street with the Boy Scouts and other civic groups boosting the sale of "Liberty Bonds" for Third Liberty Loan. Sights like this were common throughout the time that the war was occurring in Europe.

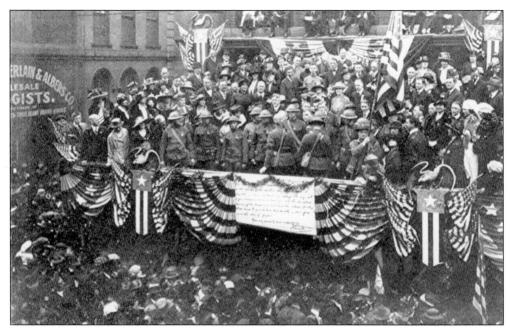

At war's end, General Tyson presented decorations to the 117th Infantry on Gay Street. Sgt. James "Buck" Karnes joined Calvin Ward and Edward Talley in receiving the Medal of Honor. Others received 84 Distinguished Service Crosses, 75 British Military Crosses, and 307 citations for Personal Bravery.

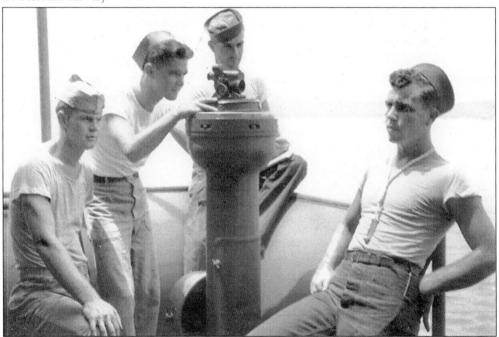

After the sinking of the U.S.S *Kanawah*, Knoxville native Seaman William W. McGill (fourth from left) was posted to the U.S.S. *Colorado* as a "gunnery captain." The ship shot down more planes than any other in the Pacific and was chosen as the honorary escort for the U.S.S. *Missouri* when the Japanese surrendered during World War II.

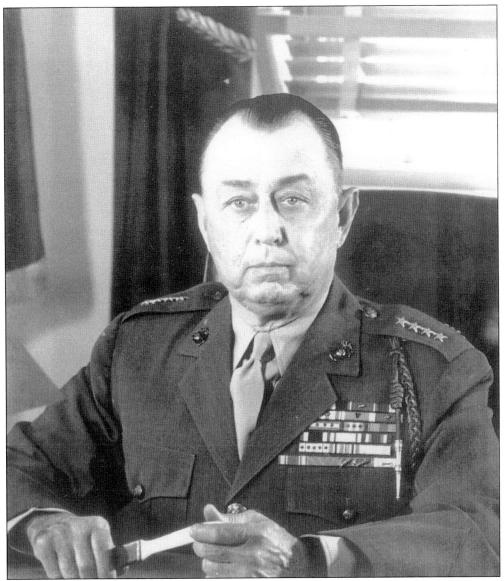

University of Tennessee ROTC cadet Marine Lt. Clifton Cates returned from World War I as the most decorated Marine to serve in the conflict. He went on to rise through the ranks of the service to achieve the rank of Commandant of the United States Marine Corps.

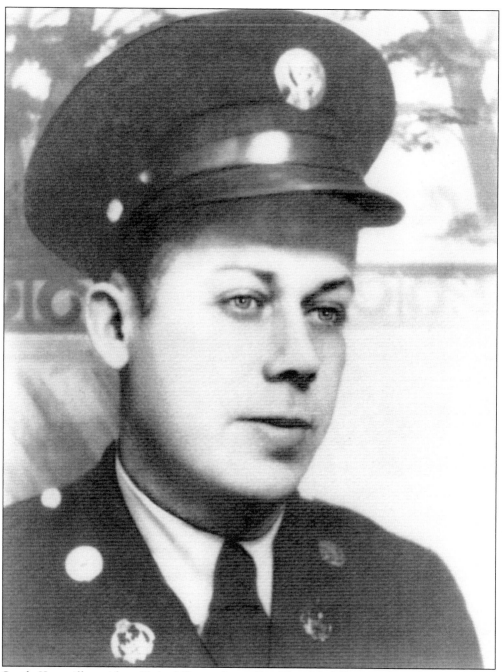

South Knoxville resident United States Army Sgt. Troy McGill entered World War II and became Knoxville's only native son in the war to receive the Medal of Honor for his actions at the Battle of Los Negros in the Pacific. He is credited with the single-handed defense of the island airstrip and killing more than 100 Japanese. Army investigators later determined most of those killed were in hand-to-hand combat. Gen. Douglas McArthur personally awarded the nation's highest award to his family.

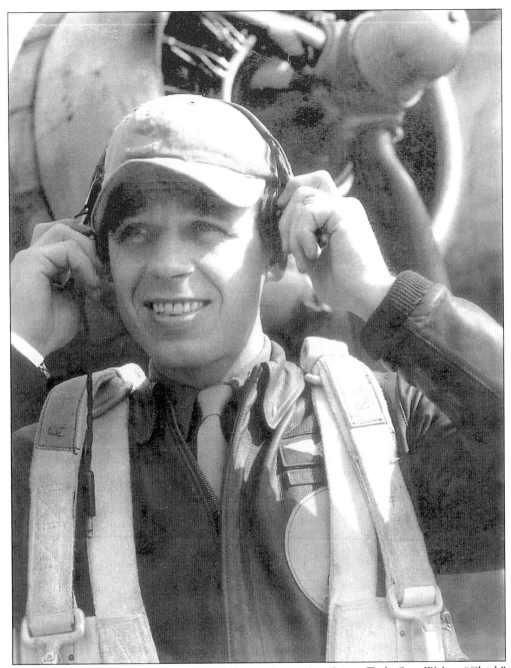

This nephew of Troy McGill is United States Army Air Corps Tech Sgt. Walter "Chick" McGill. His 390th Heavy Bombardment Group shot down more planes and flew more missions than any other in Europe. McGill received the Distinguished Flying Cross and three Bronze Stars, while his group received a Presidential Citation for their service in the war.

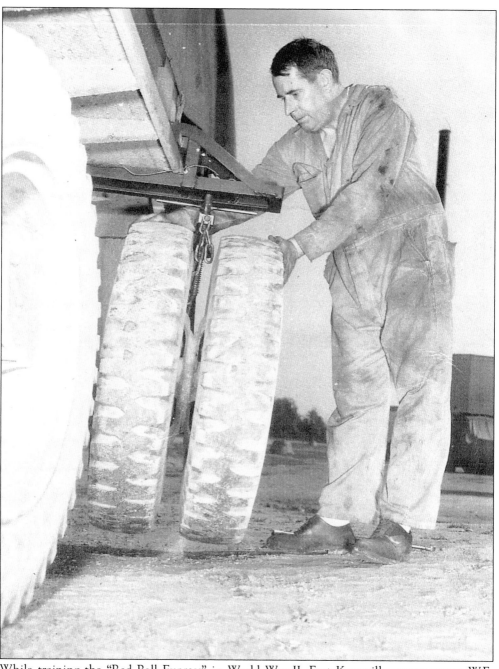

While training the "Red Ball Express" in World War II, East Knoxville garage owner W.E. Hooper invented a device that permitted a single man to change tandem tires. The reduced manpower allowed the Army to increase the number of trucks in a supply line and was featured in numerous military magazines and newspapers.

Six

CHURCHES AND
CHARITY

The diversity and strength of a city is often judged by its churches and charitable organizations. Knoxville has always put forth the effort to encourage charity among its residents and, at times, aided itself when the need was too great for any or all to do alone. The nature of East Tennesseans has always been to lend a hand to their neighbors, community, or nation when help is needed. From raising a barn to tending to a farm or business until the rightful owner is well enough to resume his position, it is done in the way charity is supposed to be, quietly and without expectation.

Since the founding of the city, religion has always played an important role and churches are as much a social gathering place as they are centers of worship. The earliest congregations of the largely Scotch-Irish settlement were Presbyterian, but religions from the old countries represented by Knoxville's citizens were also prevalent among the churches. Reform Judaism, Methodist, Catholicism, Baptist, Lutheran, and Greek Orthodox have been represented in the city from its earliest days as immigrants formed communities in Knoxville.

While churches represented the earliest charities in Knoxville, others sprang forward. Most were faith-based charities that grew out of the religions above, but some were city-oriented organizations aimed at bettering the lives of its citizens or aiding other nationally important causes. From raising a barn to raising cash and supplies for a nation at war, Knoxville has never forgotten its responsibility as a city.

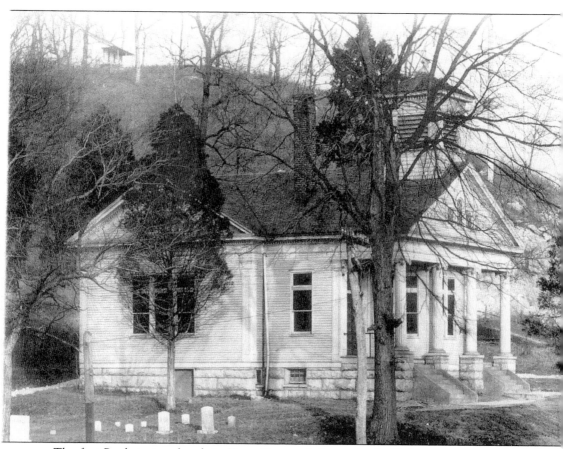

The first Presbyterian church in Knox County, Lebanon-in-the-Forks, was organized in 1791. City founder James White was its first member and Rev. Samuel Carrick served as its pastor. The church cemetery holds the remains of many of the families who helped settle Knoxville.

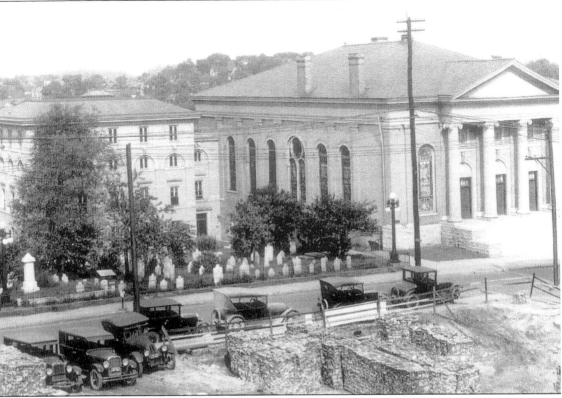

Constructed on a plot of land donated by James White for the church and cemetery, First Presbyterian Church was the first church to be built in Knoxville proper. It was active by 1793 with Rev. Sam Carrick also serving as pastor, who would also organize what would become the University of Tennessee. The cemetery of the church contains the remains of the city's founders and United States Constitution signer from North Carolina William Blount.

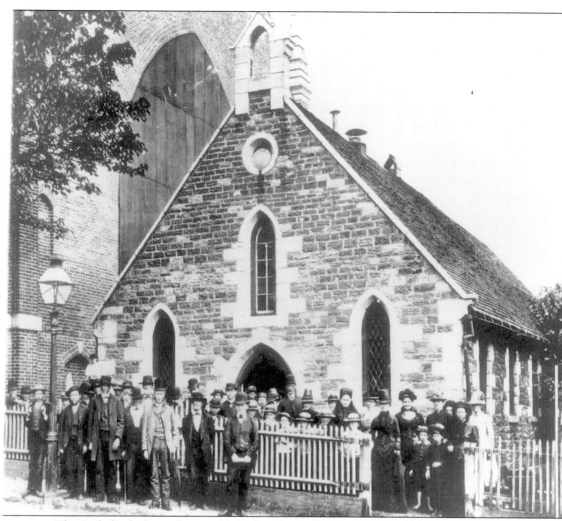

The Catholic faith was first established in Knoxville around 1809. Although small, the coming of the railroads and the influx of Irish workers in the 1850s greatly enlarged the Catholic community being served then by the Immaculate Conception. The church seen here was built by its congregation.

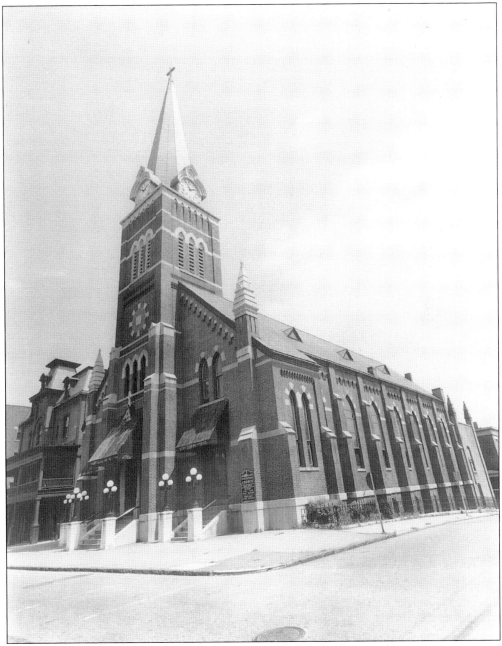

The New Immaculate Conception replaced the old church. Among the priests to serve at Immaculate Conception was former Confederate Chaplain Fr. Abram Ryan, who wrote the nationally acclaimed poem "The Conquered Banner," while residing in the city. The original manuscript is still in the possession of a Knoxville family.

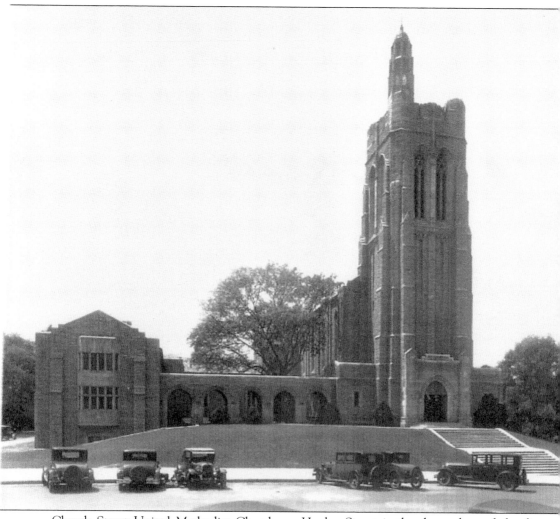

Church Street United Methodist Church on Henley Street is the descendant of the first Methodist church built in Knoxville. While the religion had been in the region since the early 19th century, it took years before a congregation was large enough to support a church in Knoxville.

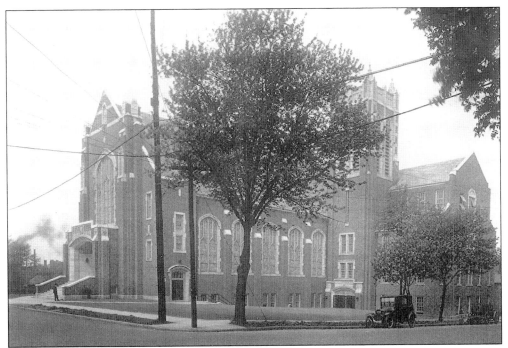

Central United Methodist Church was built in 1870 and took with it nearly half the congregation of Church Street United Methodist Church. The church seen here replaced one destroyed by fire in 1924 and is now regarded as one of the largest Methodist congregations in Knoxville.

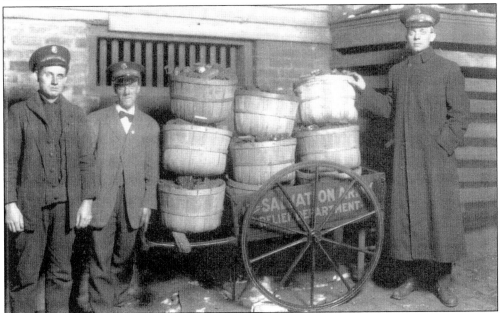

Among the earliest charitable groups established in Knoxville was the Salvation Army. This scene from around 1905 shows the organization distributing coal to the poor and indigent in the community. The Salvation Army is regarded as one of the largest and oldest continuing operating charities in the city.

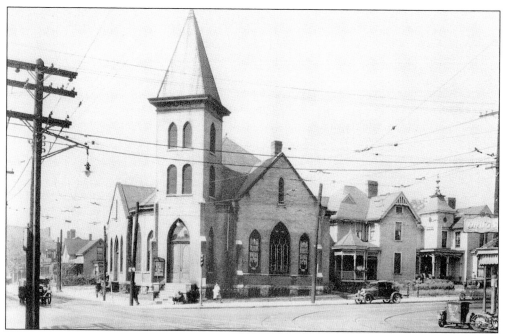

The First German Lutheran Church on Broadway and Fifth Avenue was first organized in 1869. The congregation was largely German immigrants and the church was noted for conducting all of its sermons in the German language.

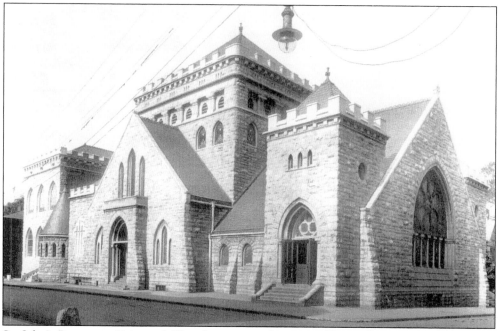

St. John's Protestant Episcopal Church came to downtown Knoxville in 1844. Although a Presbyterian theological student, Rev. Thomas Humes dropped out and returned to Knoxville where he studied the Episcopal faith and was eventually ordained. He is recognized as the "father" of St. John's Church, which operates numerous charitable organizations throughout the city.

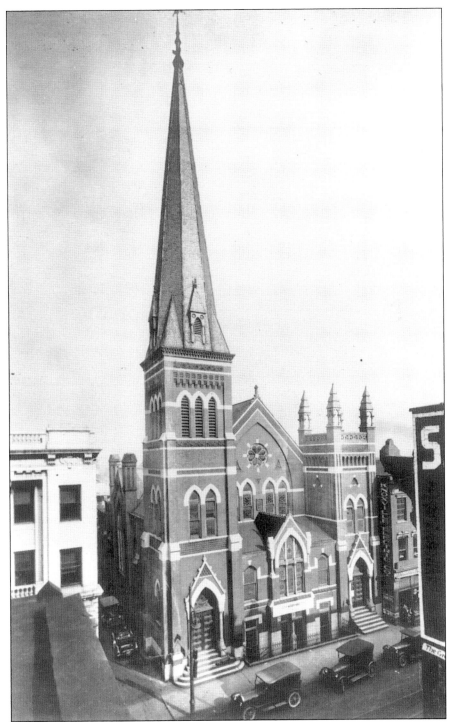

The second religion and the most populous to be established in Knox County was the Baptist, who established their first church in the city on Gay Street. This is the second First Baptist Church building erected in 1886. Downtown merchant W.W. Woodruff matched every dollar donated by members to build the church.

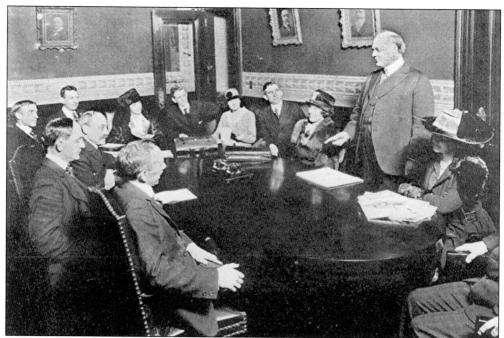

The first local Red Cross Chapter in Tennessee was established in Knoxville during World War I. This board meeting of the Knox County chapter was one of the most successful ever organized. In two campaigns to help the Red Cross, the citizens of Knoxville and Knox County raised more than $200,000.

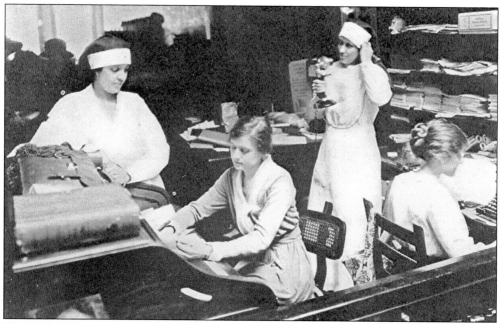

Mrs. N.E. "Whitty" Logan (seated second from the left) was a nurse who helped found the Knoxville Chapter of the Red Cross. Her work in Knoxville and near the front lines in France during the war earned her international prominence and a Medal of Commendation from World War I Comm. Gen. "Black Jack" Pershing.

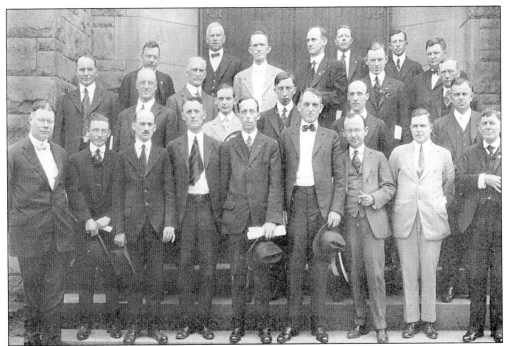

The Knoxville "Four Minute Men" were part of a nationwide association of public speakers who presented messages on behalf of Washington, D.C. to keep up public support for World War I. They spoke at intermissions of films, schools, churches, etc. Their talks were, as the title implies, four minutes each.

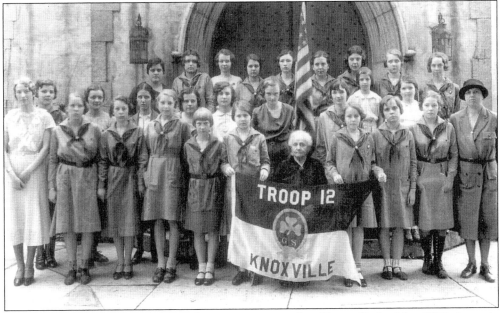

The first Girl Scout Troop, shown here, was organized in Knoxville by Mrs. W.N. Lynn in 1928. The troop was noted for their numerous charitable projects throughout the city and their work in community projects. Mrs. W.N. Wynn worked continuously with the troop and helped organize others in the city.

Knoxville High School was first built in 1909 and opened a year later with an enrollment of 646. High school attendance was not made mandatory until 1913. The high school graduated numerous prominent local and national leaders, including actress Patricia Neal, before closing in 1951.

The first Catholic high school in Knoxville, which occupied the former resident of then Knoxville mayor George Branner, is shown in this photo. The church later built a facility on what became known as Magnolia Avenue, which became the school's permanent home in the city.

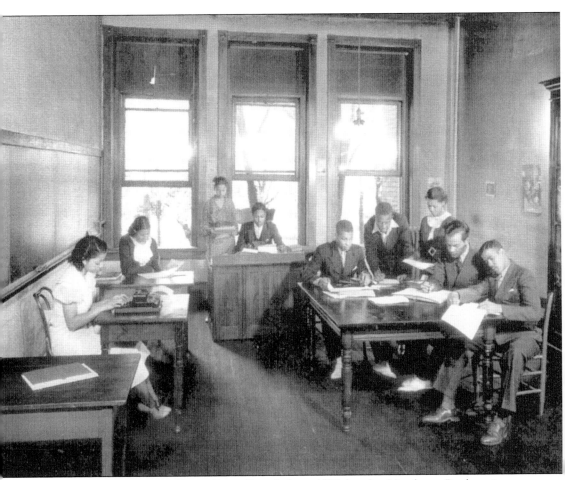

This is a scene from Knoxville College. Founded in 1875 by the Northern Presbyterian denomination, all of its presidents were Presbyterian ministers until 1951. It is one of the most respected historically black colleges in the South and noted for its service to blacks in the Southern Appalachian region.

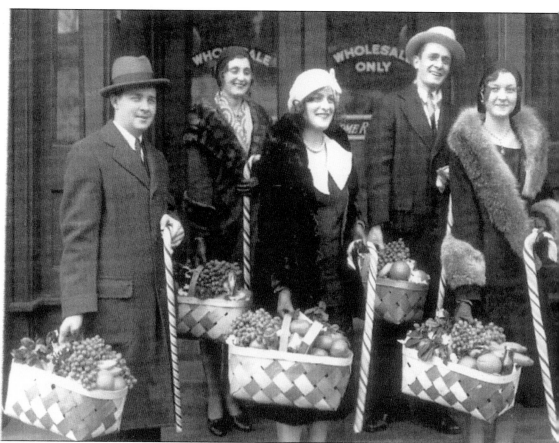

Taken Christmas 1930, this photograph shows employees from the C.M. McClung Company with their annual Christmas basket and four-foot long candy canes that were given to every employee from the janitor to the president. Christmas in Knoxville was always a holiday much celebrated in the downtown business district.

Seven

KNOXVILLE
AFTER HOURS

No matter how hard historians and pundits have tried to paint Knoxville as a city of virtuous beginnings, for more than 100 years it was a wide-open town filled with the kind of establishments city fathers would rather not discuss in polite company. In fairness, however, it was such enterprises that often led to the founding of cities like Knoxville and provided a consistent economic base for cities where these businesses were located.

East Tennessee's Scotch-Irish settlers were, by tradition, people who made good use of corn, and by 1821, 61 legal distilleries operated in Knoxville and were more than half of the city's manufacturing base. The immigrants who followed the distilleries into the Tennessee Valley from Switzerland, Germany, and other old world countries brought their own wine and brew-making recipes. In fact, the first Jewish enterprise in Knoxville was the A. Schwab and Co. located on Gay Street. It sold fruit, but also specialized in imported wines and liquors for those wanting something other than home-brew. By 1905, there were more than 160 various saloons and assorted "establishments" in the city where alcohol was freely served.

Alcohol is not the only thing that has occupied citizens' time over the years. Theaters, organized sports teams, music, and other community concerns are just as important to the city and strike a balance that keeps everything in its place. The stories behind them are just as colorful and unique. From city taverns to national treasures, Knoxvillians know how to play as hard as they work.

Scotsman and Revolutionary War officer John Chisholm was among the founders of Knoxville and opened the first tavern in 1792 on Front Street. It was the most popular gathering place in the city. Although regarded as a solid settler, he often also worked on discrete missions for Gov. William Blount.

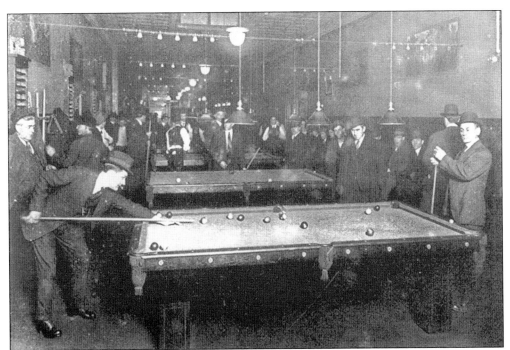

One of Gay Street's most popular gathering places was Ritter's—a billiards hall that also featured a backroom where cigars and alcohol were sold. The saloon was popular with downtown businessmen. When the Temperance movement led to the prohibition of alcohol in the city, such establishments struggled to stay in business. To fight back, numerous "speak-easy" enterprises sprung up across Knoxville. By the time of national prohibition, the city was a leader across the nation in the illegal liquor trade, in both moonshine and the "stamped variety."

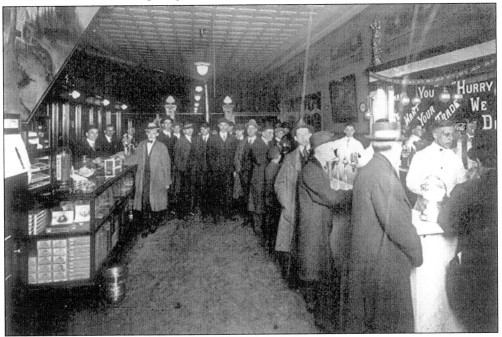

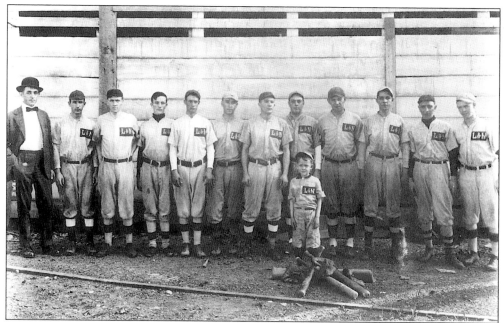

One of the early popular sports in Knoxville was baseball, with the first team being organized sometime after 1865. By the early 20th century, Knoxville businesses like the Louisville and Nashville Railroad Company sponsored teams and games in the city.

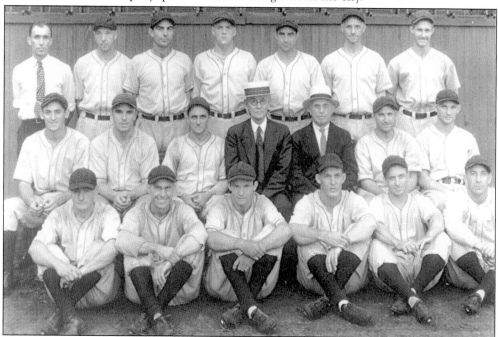

Knoxville lobbied and worked to get a minor league baseball team organized in the city and was eventually successful when its team joined the "Sally League." Team mascots have included the Indians, Reds, Pioneers, Appalachians, Smokies, and Bluejays. The Knoxville team joined the Southern League in 1964 and has served as a "farm team" for two major league franchises–the Toronto Blue Jays and the St. Louis Cardinals.

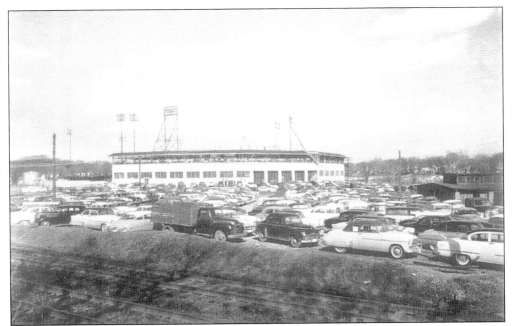

Bill Meyer Stadium was built in the 1930s near downtown and was a popular place for city residents to spend an afternoon. The team had a large following among sports fans throughout the region and was the only professional team sport in Knoxville.

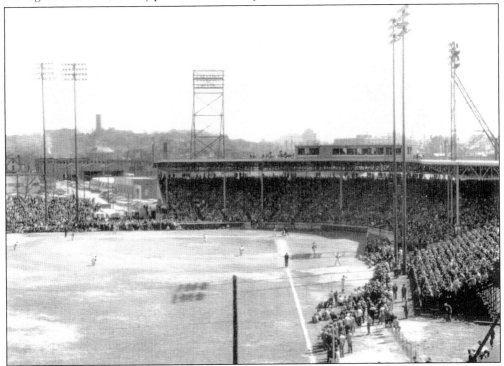

The stadium is regarded as a classic example of minor league ballpark architecture from the mid-1930s to the mid-1950s. A full roof protects the fans, and the box seat area is comprised of real box seats, with metal rails between the boxes.

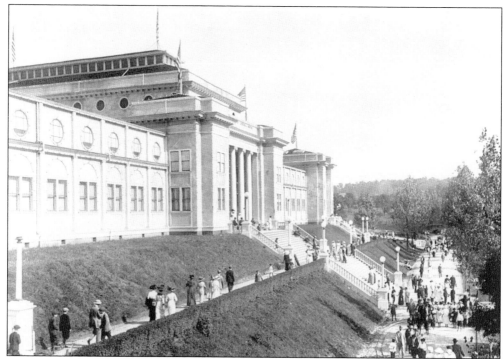

This image is from the 1913 National Conservation Exposition held in Chilhowee Park in East Knoxville. The exposition featured exhibits from eight Southern Appalachian states and focused on agriculture, manufacturing, and natural conservation. The site was home to three similar events from 1910 to 1913 and was the forerunner to the annual Tennessee Valley Agriculture & Industrial Fair.

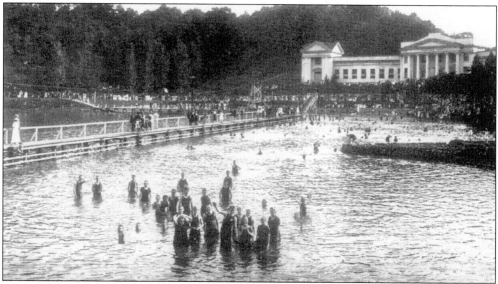

Lake Ottosee was the swimming destination in the summer of 1913. Chilhowee Park would remain a popular recreation area in Knoxville and eventually serve as a major convention site for the city through the years, especially with the adjacent addition of the nationally prominent Knoxville Zoo.

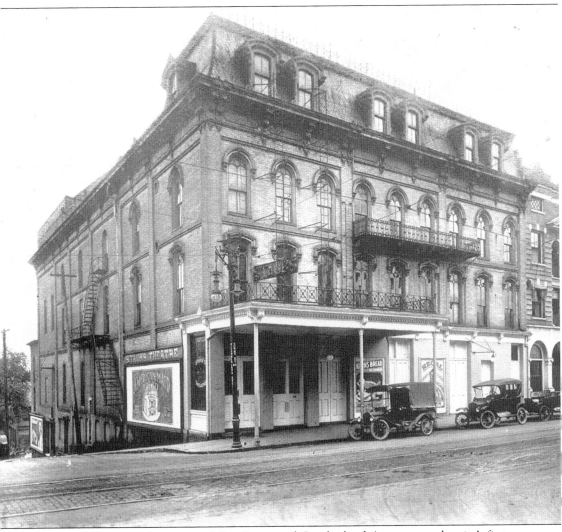

Staub's Opera House on the corner of Gay Street and Cumberland Avenue was the city's first theater. Swiss native and Knoxville tailor Peter Staub, who would later serve as city mayor and United States Consul to Switzerland, built it in 1871. The first play, the Swiss legend of William Tell, opened in 1872.

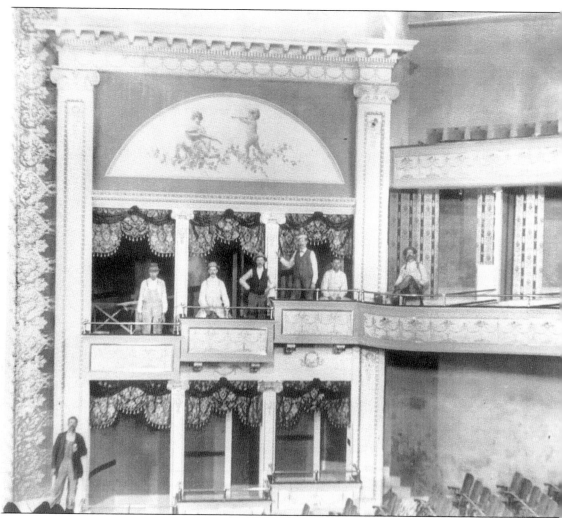

Theaters were a major part of Knoxville's after hour life for many years and brought some of the finest acts in America to the stage. This interior photo taken around the turn of the 20th century shows a group of men in one of the theaters that dominated Knoxville's early social life.

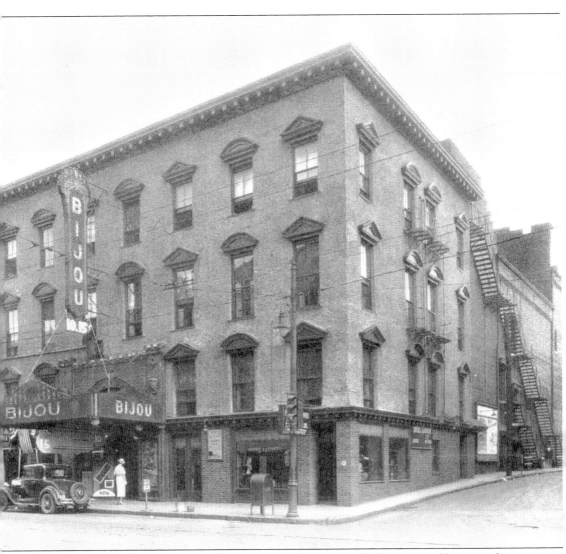

One of the most popular theaters on Gay Street was the Bijou, which was an addition to the historic Lamar Hotel. Ground was broken on it in 1908 at a cost of $50,000. In May of that year, it debuted with a performance of the George M. Cohen musical *Little Johnny Jones*.

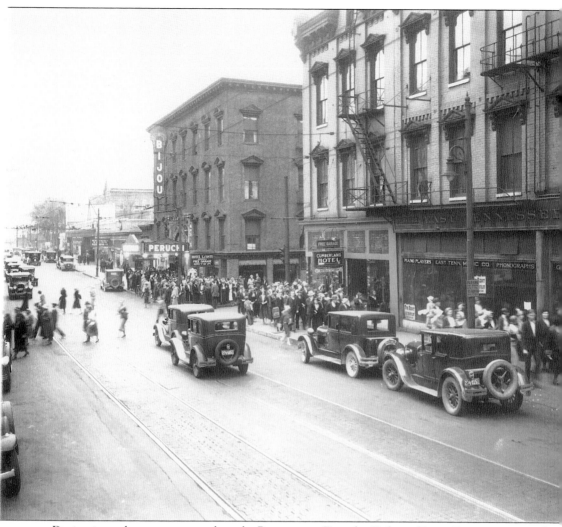

During its peak years, greats such as the Barrymores, Dorothy Gish, and Lynn Fontane appeared on the stage and crowds would line around the corner to buy tickets. The Bijou was consistently ranked as one of the premier theaters in the South until 1928.

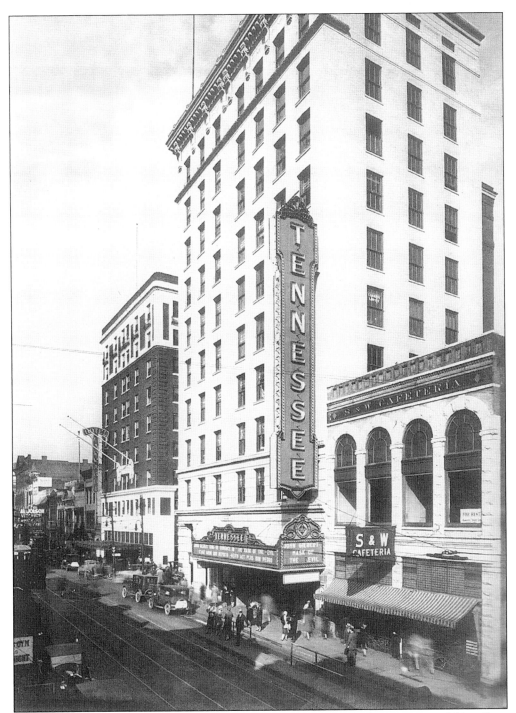

On October 1, 1928, Knoxville's Tennessee Theater opened after taking a year and $2 million dollars to build. The opening program was Clara Bow's photoplay *The Fleets In* and a concert on the $50,000 Wurlitzer Organ. For the next two decades, Knoxvillians would see such names as Helen Hayes, Tom Mix, and Desi Arnaz and hear the music of bands like the Glenn Miller Orchestra.

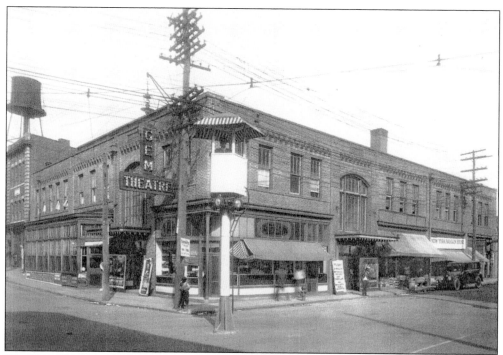

The Gem Theater, which opened in 1913, was the largest black theater in the South. The Gem featured nationally acclaimed black entertainers from across America on its stages. It also ran nickel movies on Saturday afternoon that were a favorite of patrons and their children.

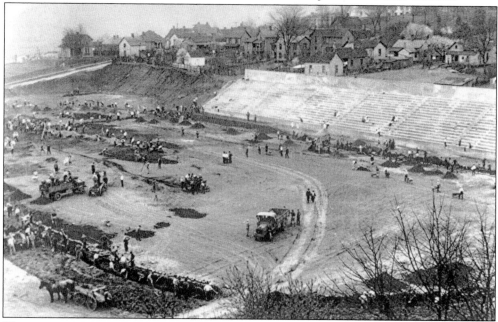

The greatest spectator attraction in Knoxville since the 1930s has been University of Tennessee football. The sport got off to a slow start when it began at the local YMCA in the 1890s. The construction of Shield-Watkins field and, eventually, Neyland Stadium surrounding the field, could accommodate more than 107,000 people.

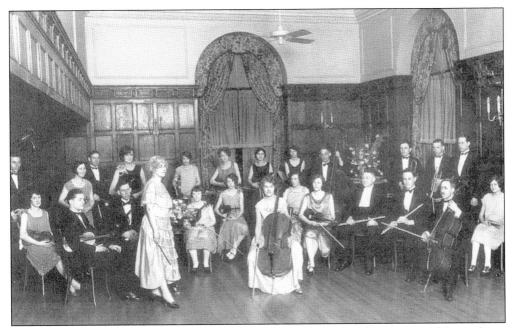

The Walburn-Clark Little Symphony, shown here in 1926, was first organized by violinist Bertha Walburn Clark as a studio ensemble in 1910. It officially became known in 1935 as the Knoxville Symphony Orchestra and remained under her direction for 11 years. The Knoxville Symphony Orchestra is today recognized as the oldest continuing orchestra in the Southeast.

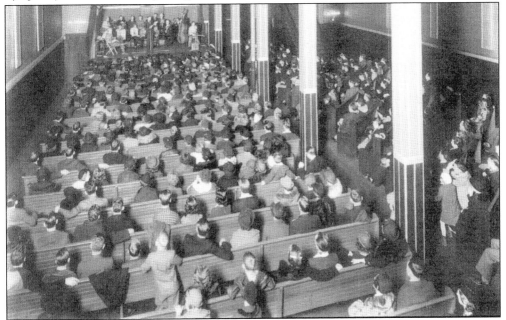

From 1935 to the 1960s, WNOX-AM's "Mid-Day Merry-Go-Round," under the direction of station manager Lowell Blanchard, brought the traditional music of East Tennessee to America. The show introduced such names as Chet Atkins, Archie Campbell, Kitty Wells, Roy Acuff, the Carter Family, and countless other famous country music entertainers to the stage for the first time.

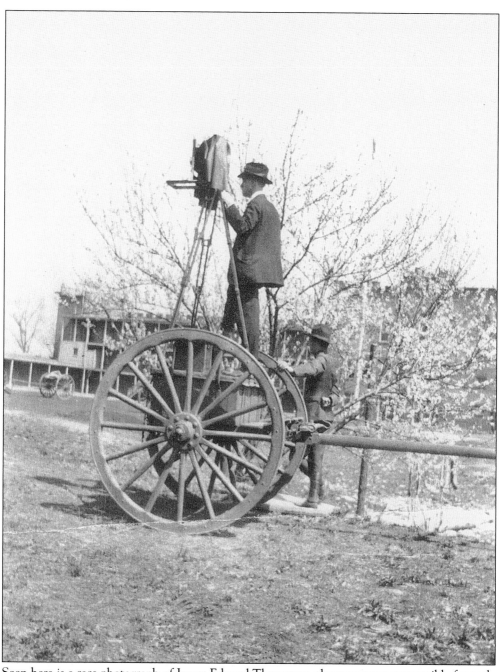

Seen here is a rare photograph of James Edward Thompson, the man most responsible for early photographs of Knoxville and East Tennessee. Jim Thompson often shot his photographs from the wagon seen here. His pictures are, in many cases, the only ones that exist of the city.

Jim Thompson established Thompson Photos in Knoxville and became regarded not only as a great photographer, but also as one of the nation's leading developers and finishers. He is also the unsung hero of aiding in the development of the Smoky Mountains National Park.

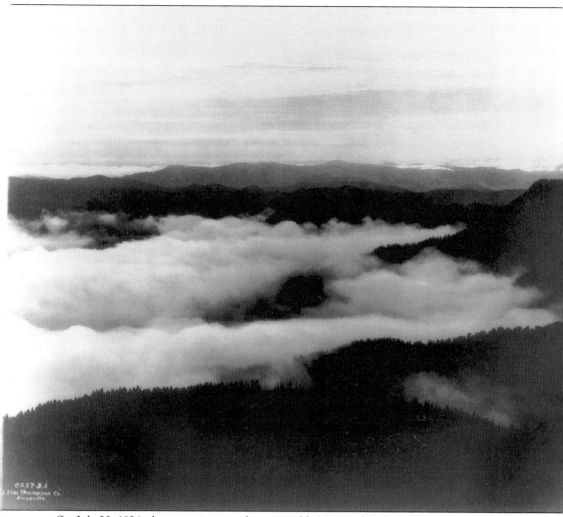

6557-B-S
© Jim Thompson Co.
Knoxville

On July 30, 1924, the committee studying possible National Park declarations was unimpressed with descriptions it had read describing the Smoky Mountains. Thompson greatly enlarged photos he had taken through the years while hiking and they alone are credited with changing the minds of the Washington committee and placing the region into consideration.

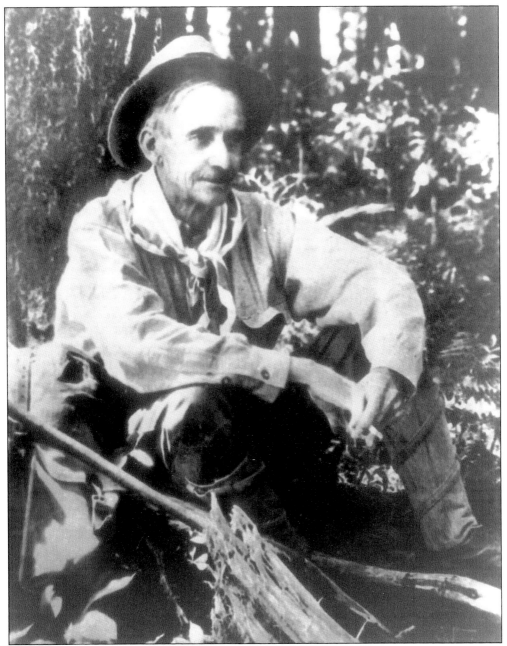

What Jim Thomson did with photographs to make the Smoky Mountains into a National Park, Horace Kephart did with words. He was influential in placing the Appalachian Trail along the ridge of the Smoky Mountains Range and his book *Our Southern Highlanders* is still regarded as a classic about life in the Smoky Mountains.

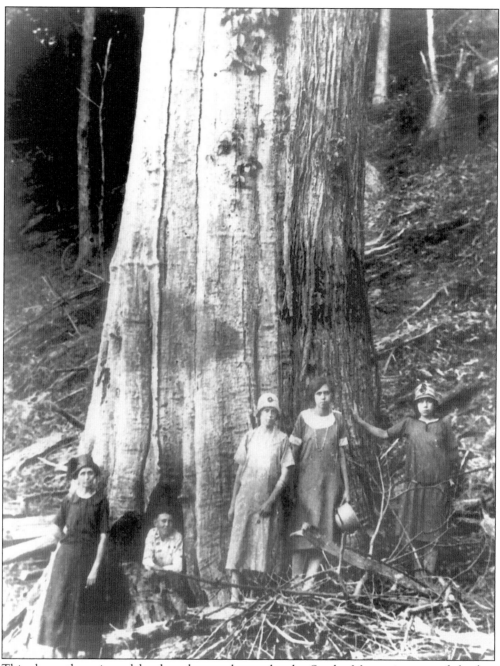

This shows the primeval hardwood trees that make the Smoky Mountains one of the last remaining hardwood forests in the world. The National Park project involved thousands of Knoxvillians and schoolchildren who donated pennies during the Great Depression to help raise money to purchase the land needed for the park.

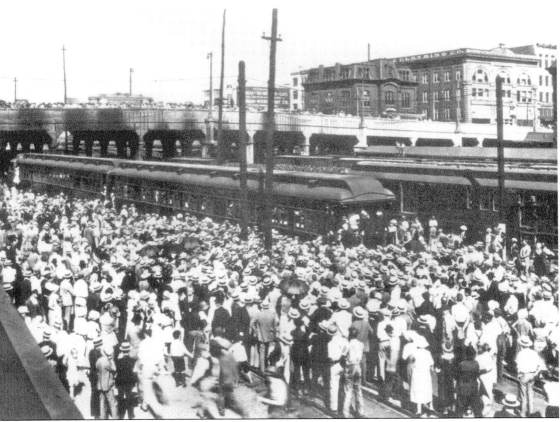

Thousands of Knoxvillians gathered at the Southern Railroad Yards in 1940 to watch as President Franklin D. Roosevelt arrived in the city on a special rail car for the dedication of the newly created Smoky Mountains National Park. People began gathering at the site before dawn to get a glimpse of the President.

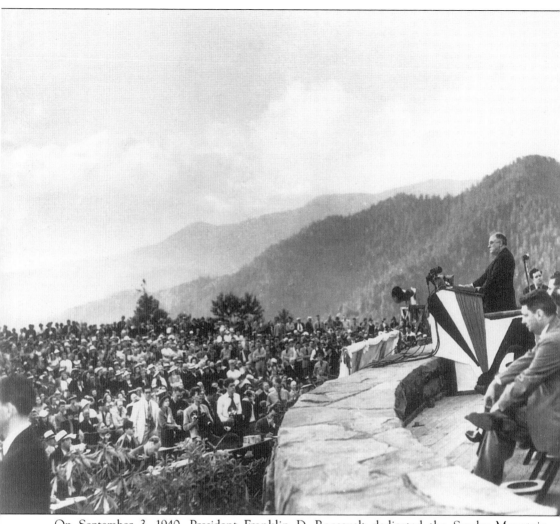

On September 3, 1940, President Franklin D. Roosevelt dedicated the Smoky Mountain National Park to a standing-room only crowd. While seen as a crowning achievement for his administration, it was not without controversy or political opposition in the region. The series of hydroelectric dams built in the Tennessee Valley in the 1930s had removed 15,000 families, and with the park's creation, 4,000 families were displaced from their ancestral homes.

ACKNOWLEDGMENTS

Collecting the images of Knoxville and finding those that have not been published repeatedly has taken the efforts and trust of many people to gain access to original photographs and negatives. Being a journalist and not an archivist or librarian with unfettered access to collections has made the process all the more difficult. To that end, I have to thank Mike Crowder and his family at whose home I spent countless hours over the last four months going through negatives from his brother's estate and finding those that would fit within the context of Arcadia's *Images of America* series. The never-before-seen images of Knoxville's industrial life are a priceless treasure that would not have been possible had I gone to the usual sources for photographs.

David K. Marsh of Fulton Bellows and Components, Inc. was another individual who took time to help me go through and unravel the myths and legends that have surrounded one of Knoxville's best-kept industrial secrets and provided me with the photographs needed to present an entire chapter on a company of which little is known, but much is heard.

Other individuals who deserve thanks for locating photographs of the city include Tennessee Sen. Tim Burchett, Fred Reagan, Janell Turner, Jim Burkhart, Sam and Linda Taylor, Linda Lewanski, Andrew and Suzie Pont, Joe Lay, Marlene Barbour, Judge David Creekmore, and Lloyd Daugherty. Their assistance, support, and patience have been invaluable.

BIBLIOGRAPHY

Amis, Reese T. *Knox County in the World War*. Knoxville: Knoxville Lithographic Company, 1919.

Deadrick, Lucille. *Heart of the Valley: A History of Knoxville, Tennessee*. Knoxville: East Tennessee Historical Society, 1976.

Rothrock, Mary. *The French Broad-Holston Country*. Knoxville: East Tennessee Historical Society, 1946.

Creekmore, Betsy. *Knox County, Tennessee*. Virginia Beach: The Donning Company Publishers, 1988.

Hooper, William E. *Tennessee History Classroom*. Gatlinburg: Tennessee Online, 1996.

Hooper, William E. *The Volunteer Chronicles*. Gatlinburg: Tennessee Online, 2001.

Fribourg, Henry A. *An Early History of Temple Beth El Temple*. Knoxville: Beth-El, 2002.

Mall, Kermit L. *The Oxford Companion to the Supreme Court of the United States*. New York: Oxford UP, 1992.

Troops, Connie M. *Great Smoky Mountains*. Stillwater, Minnesota: Voyageur Press, 1992.